THE ART OF THE
NATIONAL PARKS
COLORING BOOK

THE ART OF THE
NATIONAL PARKS
COLORING BOOK

BY *Fifty-Nine Parks*

EARTH AWARE

SAN RAFAEL • LOS ANGELES • LONDON

CONTENTS

THE NORTHWEST

THE PACIFIC

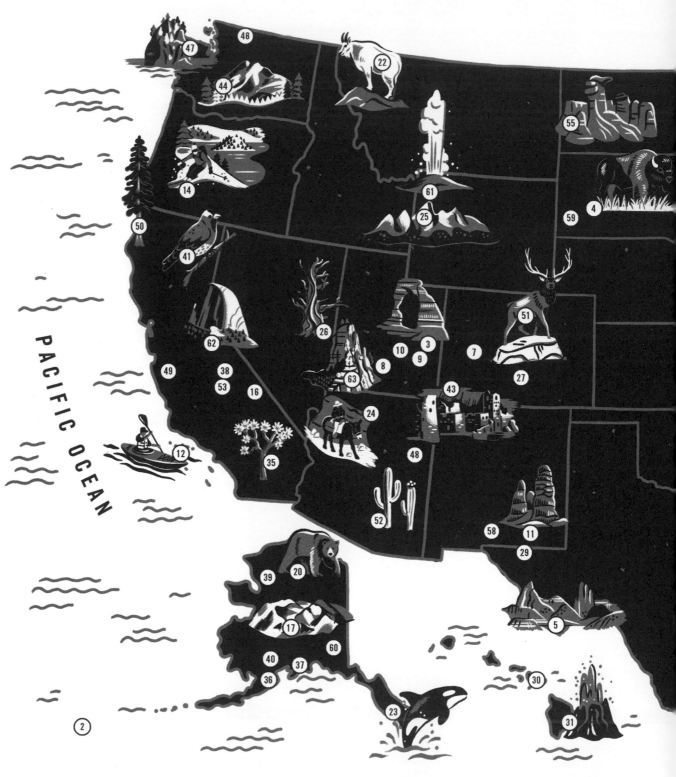

PACIFIC OCEAN

2

01. ACADIA (ME)
02. AMERICAN SAMOA
03. ARCHES (UT)
04. BADLANDS (SD)
05. BIG BEND (TX)
06. BISCAYNE (FL)
07. BLACK CANYON (CO)
08. BRYCE CANYON (UT)

09. CANYONLANDS (UT)
10. CAPITOL REEF (UT)
11. CARLSBAD CAVERNS (NM)
12. CHANNEL ISLANDS (CA)
13. CONGAREE (SC)
14. CRATER LAKE (OR)
15. CUYAHOGA VALLEY (OH)
16. DEATH VALLEY (CA/NV)

17. DENALI (AK)
18. DRY TORTUGAS (FL)
19. EVERGLADES (FL)
20. GATES OF THE ARCTIC (AK)
21. GATEWAY ARCH (MO)
22. GLACIER (MT)
23. GLACIER BAY (AK)
24. GRAND CANYON (AZ)

25. GRAND TETON (WY)
26. GREAT BASIN (NV)
27. GREAT SAND DUNES (CO)
28. GREAT SMOKY MTNS. (TN/NC)
29. GUADALUPE MTNS. (TX)
30. HALEAKALA (HI)
31. HAWAII VOLCANOES (HI)
32. HOT SPRINGS (AR)

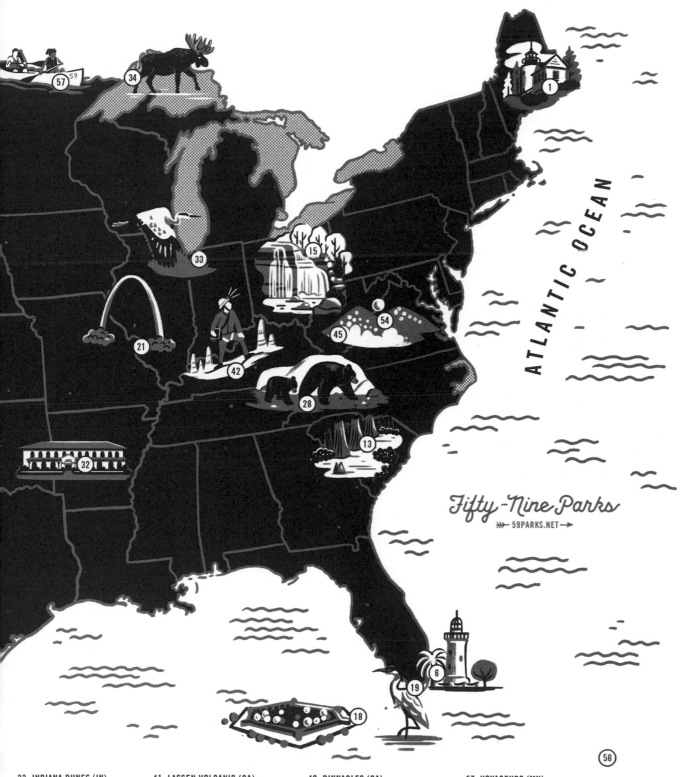

Fifty-Nine Parks
⟫ 59PARKS.NET →

ACADIA NATIONAL PARK

First a national monument in 1916, Acadia National Park is known for its jagged Atlantic coastline, sprawling woodlands, and scattered lakes that stretch across 47,000 acres. Acadia consists of half of the island known as Mount Desert, several smaller islands, and the Schoodic Peninsula. It's the easternmost national park in the United States, providing stunning views of the Atlantic's waves crashing against the highest rocky headlands on the coastline. The definitive lighthouses and fishing boats of the region adorn the breathtaking shoreline.

THE NORTHEAST | STATE: MAINE | **ARTIST:** TELEGRAMME PAPER CO.

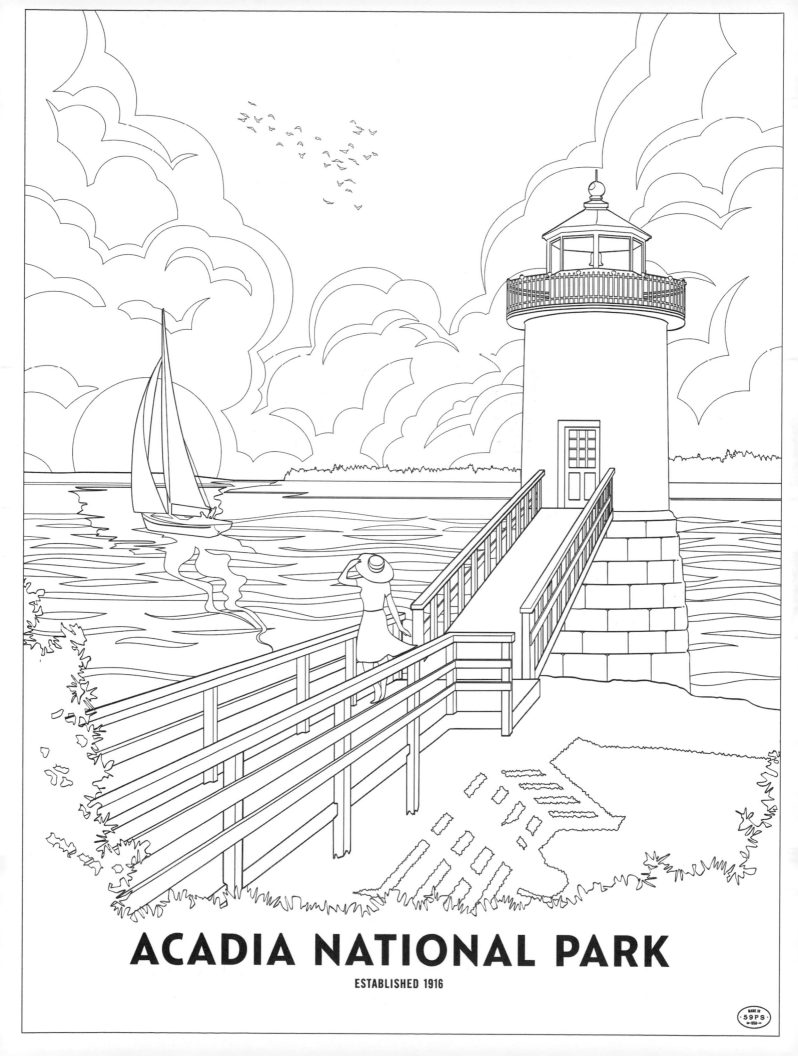

ACADIA NATIONAL PARK

ESTABLISHED 1916

MAMMOTH CAVE NATIONAL PARK

Two vastly different landscapes—the lush countryside and the dark caverns beneath—make up Mammoth Cave National Park. Most of the water in the area is absorbed into the soil, predominantly made of decomposed limestone. Millions of years of dripping water has resulted in an underground pantheon. With nearly 400 miles of rooms and passageways, Mammoth Cave is by far the longest cave system in the world. Stalagmites and stalactites jut from the shifting ceilings and floors. Aboveground, the Green River runs throughout the park, rounding grassy bends and lurching down steep inclines.

THE SOUTHEAST | STATE: KENTUCKY | **ARTIST:** NICOLAS DELORT

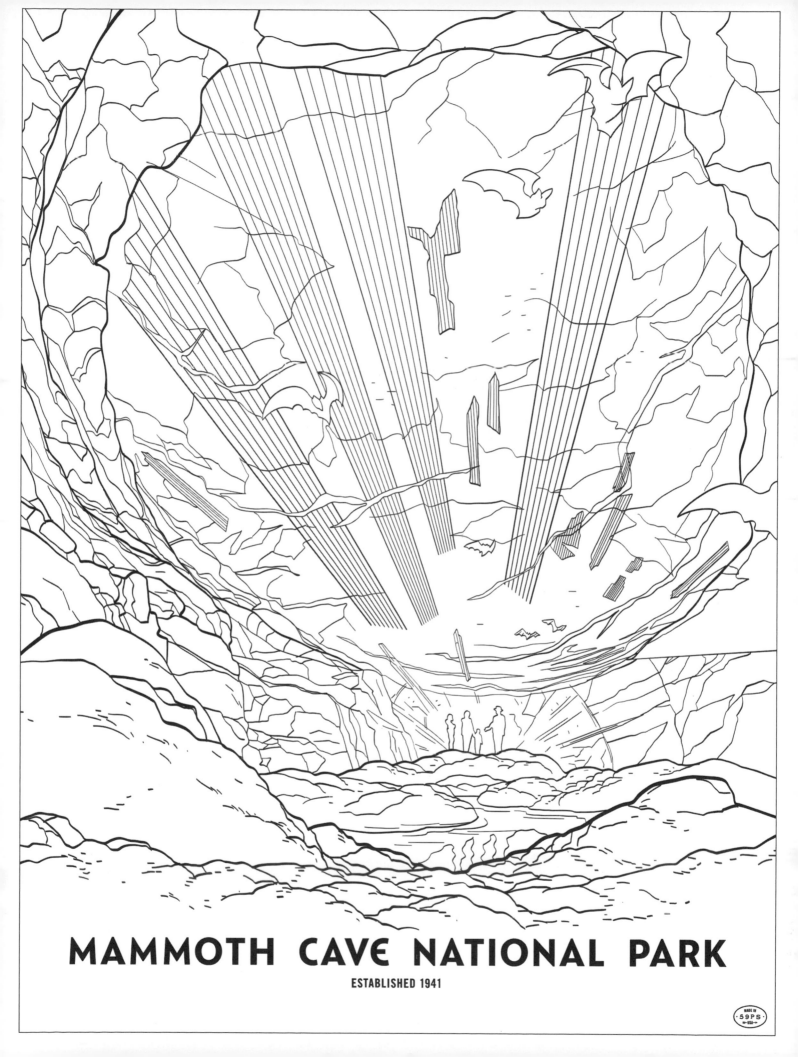

MAMMOTH CAVE NATIONAL PARK

ESTABLISHED 1941

SHENANDOAH NATIONAL PARK

Sprawling and diverse forests thrive in Shenandoah National Park, providing a protected home for myriad species of trees. The park offers scenic views of the Blue Ridge Mountains and the rolling hills of the countryside. Water trickles down through brooks and streams, then tumbles down waterfalls en route to the Atlantic Ocean. The western side of the park is home to the Shenandoah River, a fifty-six-mile tributary that runs in the shadow of the Appalachian Mountains. Despite its beauty, the land has a bloody history. First the native peoples were displaced, and then the farmers who later settled in their absence. Abandoned farms coupled with moss that hangs from branches give these parts a haunting, funereal feel.

THE SOUTHEAST | STATE: VIRGINIA | **ARTIST:** BRIAN EDWARD MILLER

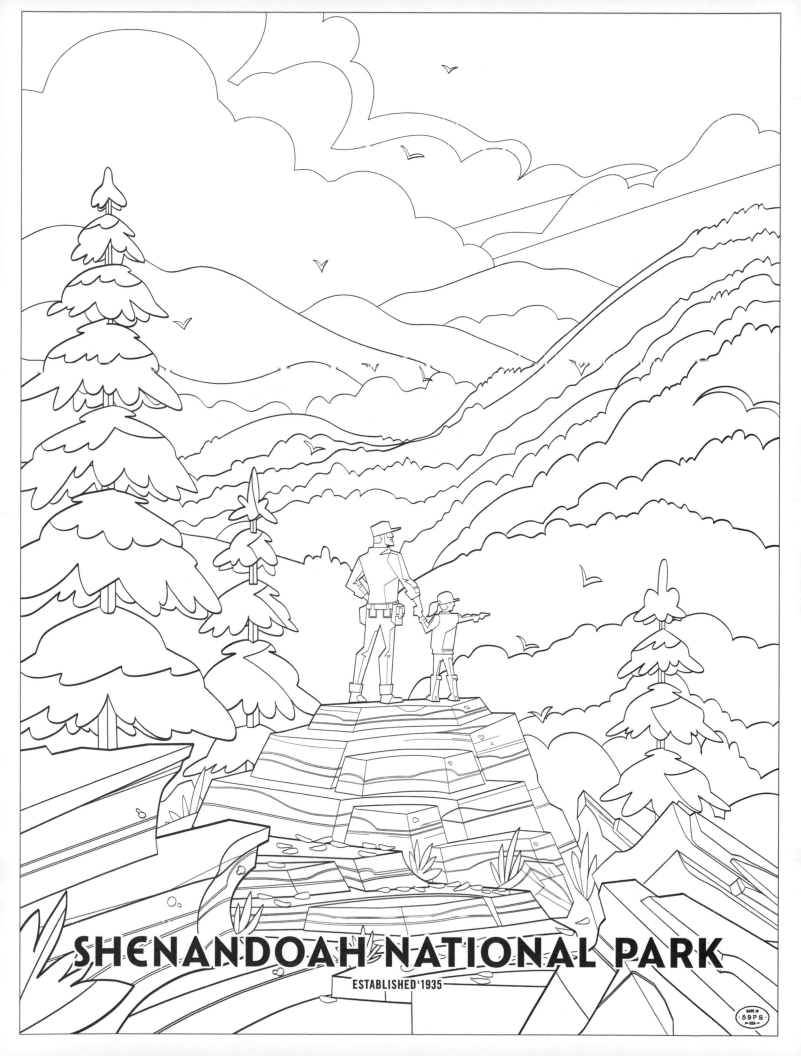

NEW RIVER GORGE NATIONAL PARK

Over 72,000 acres of land and 53 miles of free-flowing river form New River Gorge National Park. Though millions of years old, the New River continues to carve out the longest and deepest river gorge in the Appalachian Mountains. The West Virginia stretch of the New River is a whitewater rafting mecca. Above the river stands a 1,700-foot-long bridge, one of the longest and highest single-span bridges in the world, which attracts bungee and BASE jumpers from across the globe. Abandoned human settlements nestled within the gorge date back to the mining boom of the late eighteenth century and now lay overtaken by foliage.

THE SOUTHEAST | STATE: WEST VIRGINIA | **ARTIST:** BRAVE THE WOODS

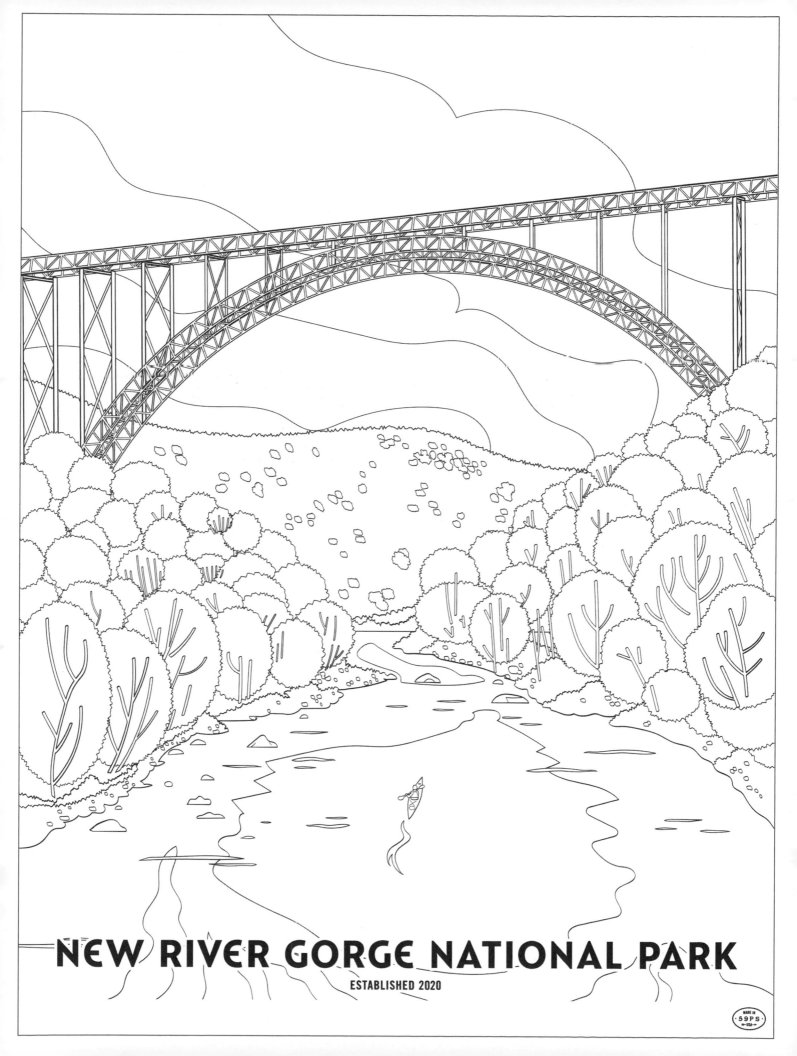

NEW RIVER GORGE NATIONAL PARK

ESTABLISHED 2020

GREAT SMOKY MOUNTAINS NATIONAL PARK

Aptly named for its perpetual fog, Great Smoky Mountains National Park is the most visited national park in the United States. The Smokies are filled with wildflowers and waterfalls. Here you can stand atop the nearly 1,500-foot-high trail dubbed the Chimney Tops and gasp at the expanse of mossy green hills. Trout, shiners, suckers, and bass populate the naturally occurring streams and the more than one hundred waterfalls in the park. Laurel Falls, perhaps the most well-known waterfall in the park, contains an endless rush of water that feeds into the brooks and streams swirling through the hollows and hills of this living, breathing marvel of nature.

THE SOUTHEAST | STATE: NORTH CAROLINA, TENNESSEE | **ARTIST:** CHRIS TURNHAM

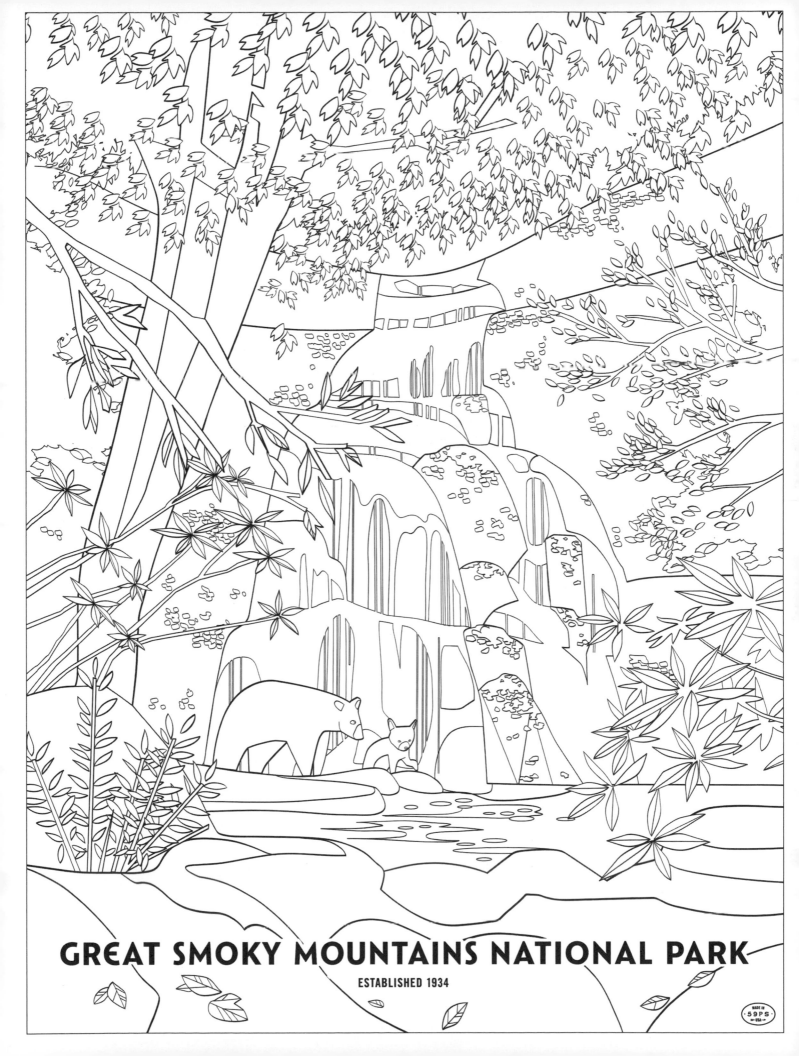

GREAT SMOKY MOUNTAINS NATIONAL PARK

ESTABLISHED 1934

CONGAREE NATIONAL PARK

Named for the river that flows through it, Congaree National Park boasts some of the tallest trees in the eastern United States. Congaree is a floodplain or bottomland hardwood forest. Less than 1 percent of these original bottomland hardwood forests still exist. The forest is filled with deciduous and evergreen hardwood trees. They thrive in the nutrient rich muck produced by seasonal floods. Oaks, sweet gums, tupelo, and bald cypress are plentiful here. Designated an old-growth forest, the area conserves some of the tallest trees in the world, including a 169-foot-high loblolly pine, and cypress trees that are over 500 years old.

THE SOUTHEAST | STATE: SOUTH CAROLINA **| ARTIST:** AARON POWERS

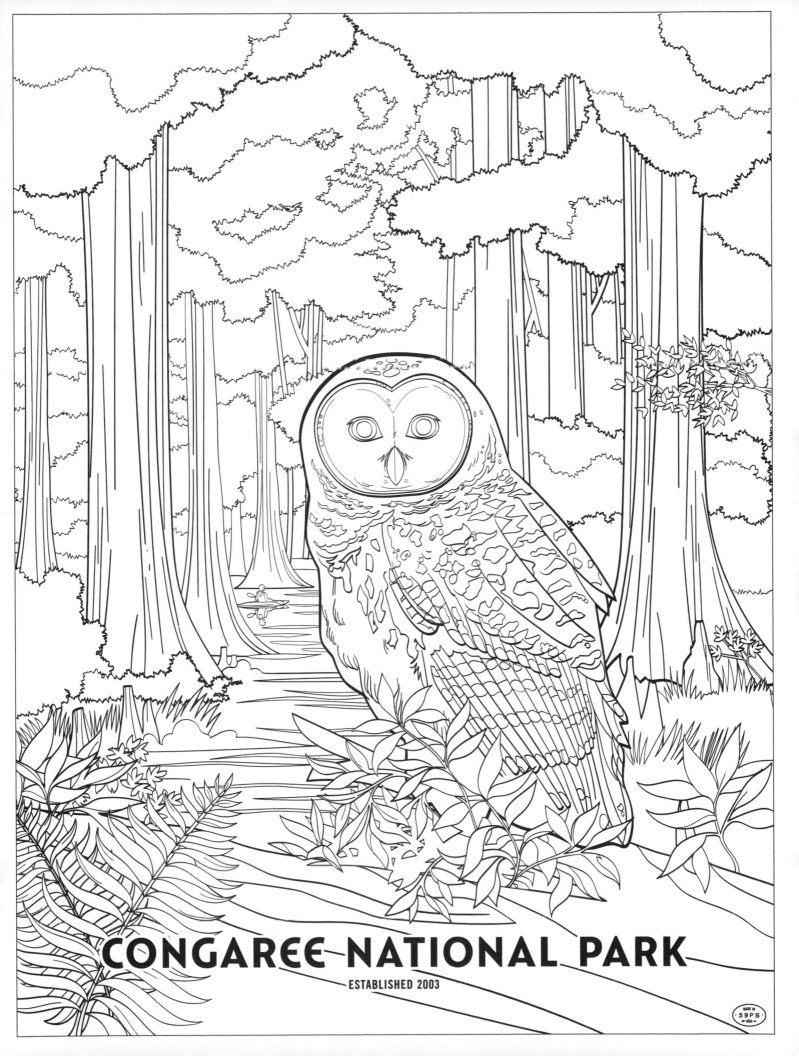

CONGAREE NATIONAL PARK

ESTABLISHED 2003

BISCAYNE NATIONAL PARK

At ninety-five percent water, Biscayne is one of the largest marine sanctuaries in the US National Parks system. The thirty-five-mile-long lagoon of Biscayne Bay hosts bottlenose dolphins and Florida manatees. Colonies of spiky polyps, sponges, and sea whips occupy the coral where nearby pork fish and gobies swim alongside laconic schools of giant sea turtles. Above sea level there are naturally occurring spindly mangroves that sway in the sea breeze, providing a home for mollusks and crustaceans. Biscayne Bay shelters a plethora of endangered species, including swallowtail butterflies and small-tooth sawfish. Home to brown pelicans, roseate spoonbills, and tricolored herons, Biscayne National Park is also a haven for birdwatchers.

THE SOUTHEAST | STATE: FLORIDA | **ARTIST:** JUSTIN SANTORA

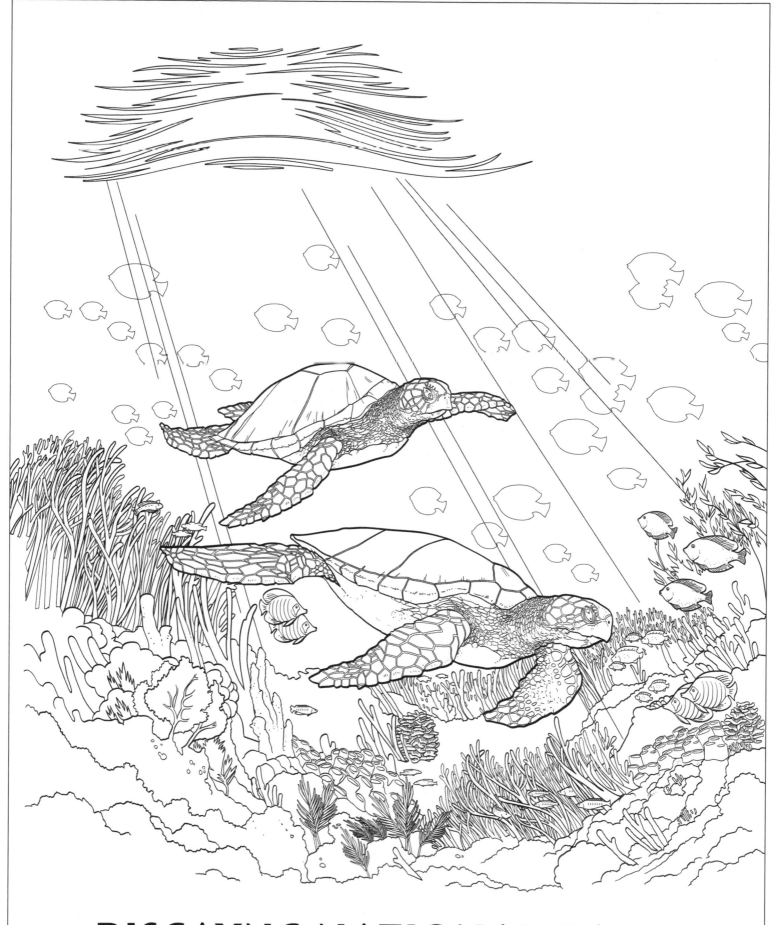

BISCAYNE NATIONAL PARK

ESTABLISHED 1980

DRY TORTUGAS NATIONAL PARK

Save for a collection of tiny islands accessible only by boat or plane, Dry Tortugas National Park is 99 percent water. The waters were once such a fertile source of sunken treasure that they made the Key West area one of America's wealthiest cities per capita. In 1908, President Theodore Roosevelt designated the area a federal bird sanctuary. During low tide, visitors can walk along the thin strip between the bush and the Garden Key and watch for the more than 300 species of birds residing there. The water surrounding Garden Key hosts some of the most vibrant and colorful coral reefs in the United States and houses myriad species of fish and turtles.

THE SOUTHEAST | STATE: FLORIDA | **ARTIST:** OWEN DAVEY

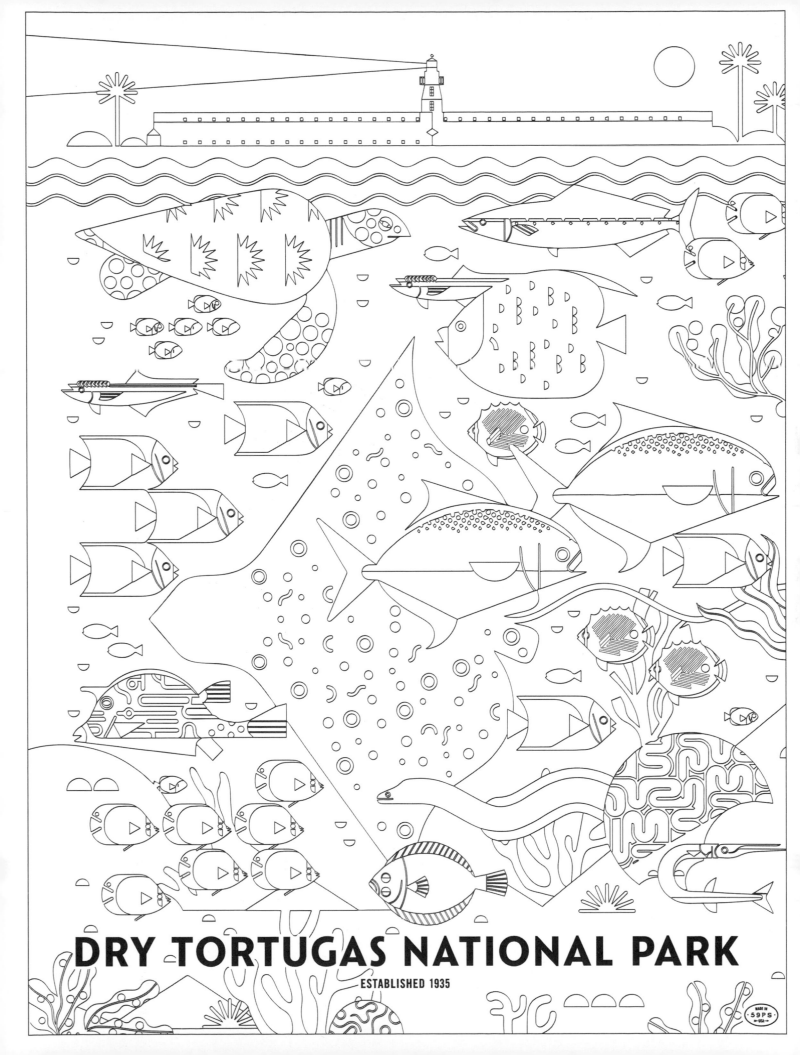

EVERGLADES NATIONAL PARK

A mixture of ocean water from the Florida Bay and the water of the Okeechobee River creates swampy forests that make up the largest tropical wilderness in the United States: Everglades National Park. Miles and miles of forests, marshes, and hammocks. Interspersed small islands, many of them never discovered. An abundance of wispy mangroves thriving in the shallow brackish water. The result is one of the most complex and interconnected ecosystems in the world. It is a protected biosphere, a World Heritage Site, and a Wetland of International Importance. Thus, the Everglades is arguably the most carefully protected area in the United States.

THE SOUTHEAST | STATE: FLORIDA **| ARTIST:** TWO ARMS INC.

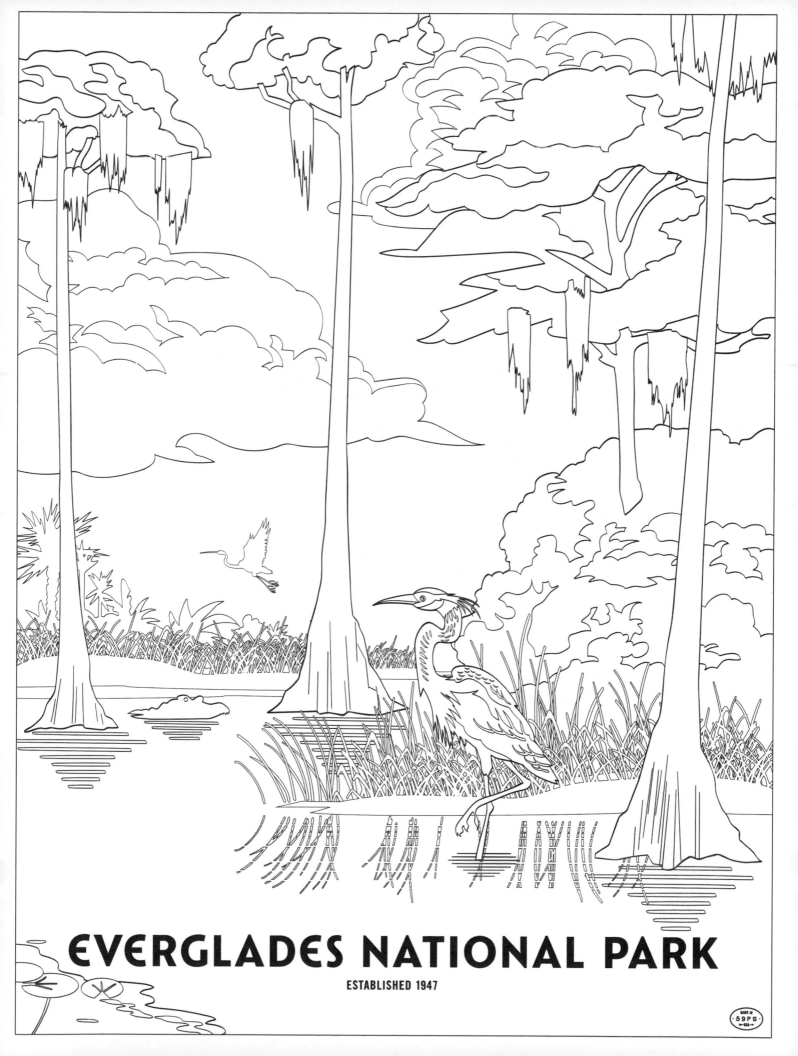

EVERGLADES NATIONAL PARK

ESTABLISHED 1947

VIRGIN ISLANDS NATIONAL PARK

Encompassing nearly 15,000 acres, Virgin Islands National Park has pristine beaches, tropical forests, and vivid seascapes. The inland tropical rainforests are home to deer, pigs, wild donkeys, and myriad species of ferns and trees. Some of the forests on St. John have only recently regrown after being cleared to make way for sugar plantations during the eighteenth century. The Reef Bay Sugar Factory was one of many plantations on the island that produced sugarcane, molasses, and rum for export to the United States and Europe during the eighteenth and nineteenth centuries. In 1733, the island was home to one of the most impactful slave rebellions. Preserved plantation sites throughout the park offer stirring insights into the history of the island.

THE SOUTHEAST | STATE: VIRGIN ISLANDS | **ARTIST:** STUDIO MUTI

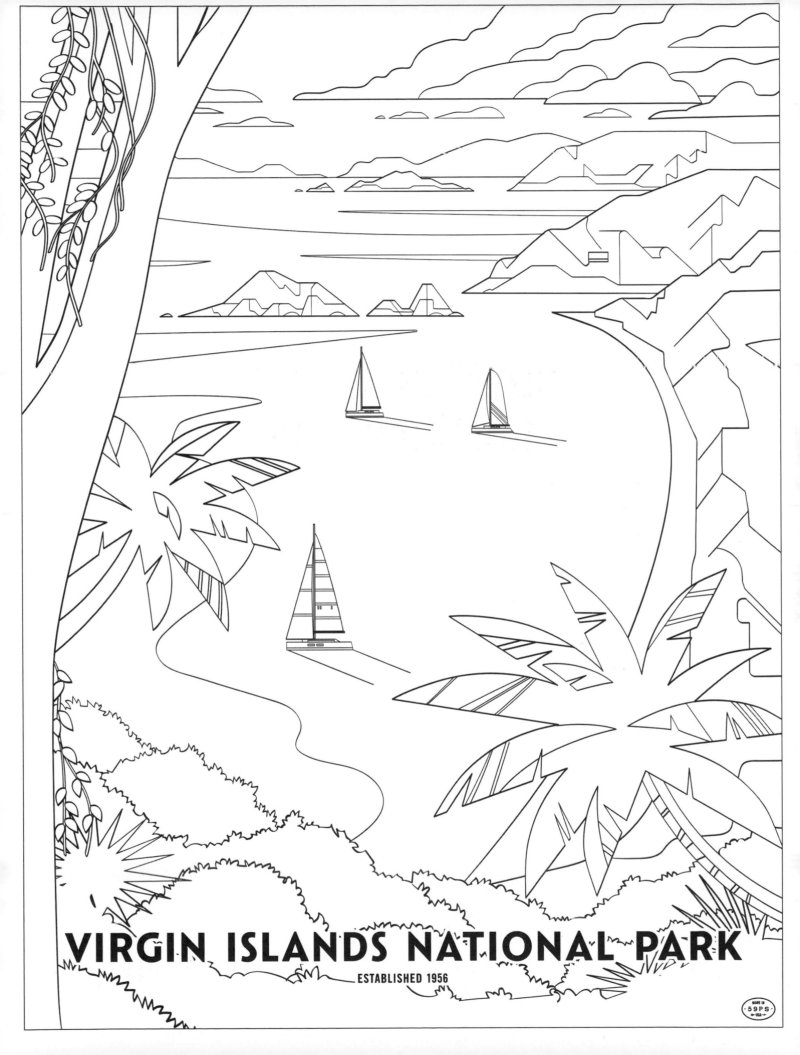

VIRGIN ISLANDS NATIONAL PARK

ESTABLISHED 1956

CUYAHOGA VALLEY NATIONAL PARK

The sinuous Cuyahoga River flows through Cuyahoga Valley National Park's lush woody floodplains, its rolling and sprawling hills, and its winding ravines. Cuyahoga is also the rare park that can be enjoyed via locomotive. The Cuyahoga Scenic Railroad is one of the oldest and longest recreational railroad jaunts in the country, perfect for seeing the yellow blaze and scarlet rouge of the woodlands' oak and maple leaves during autumn. Also popular at this park is the beloved waterfall with a sixty-foot drop: Brandywine Falls. Surrounded by the bustle of modern life, the banks of the Cuyahoga are a protected escape, a serpentine invitation to a journey without a destination.

THE MIDWEST | STATE: OHIO **| ARTIST:** KIM SMITH

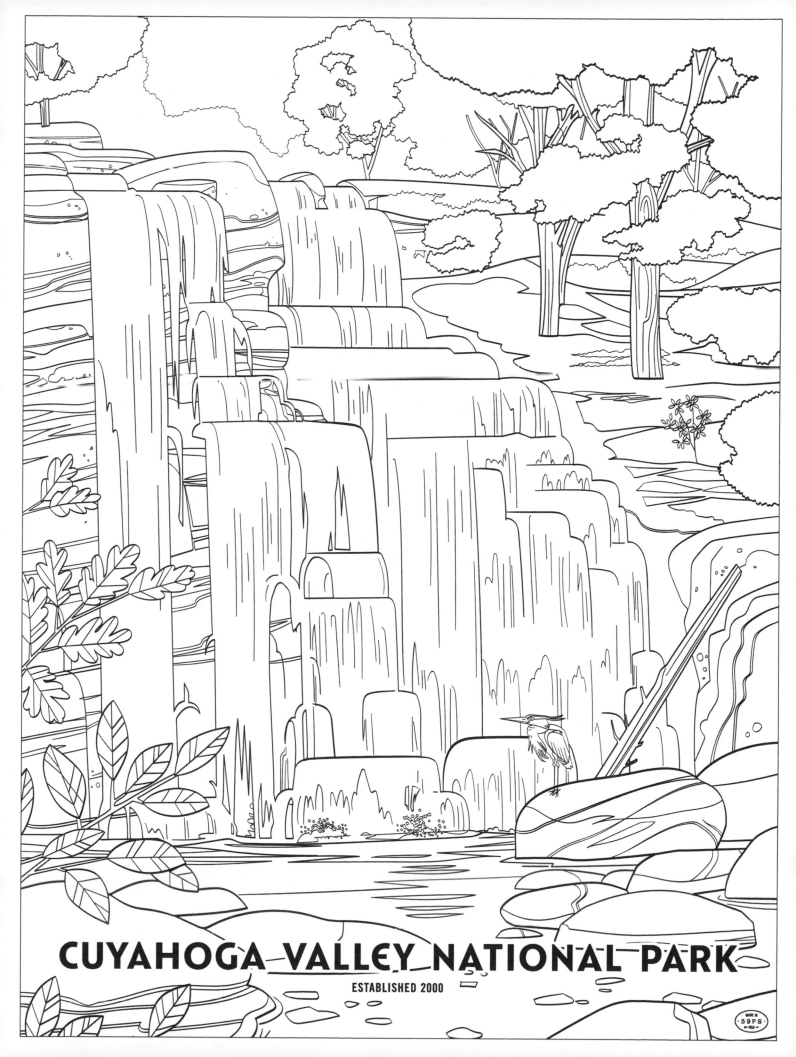

CUYAHOGA VALLEY NATIONAL PARK

ESTABLISHED 2000

ISLE ROYALE NATIONAL PARK

Located deep in Lake Superior, Isle Royale National Park is a forty-five-mile-long island of glacier-scarred volcanic rock. Even though it is the most remote park in the contiguous United States and is only accessible by boat or plane, Isle Royale might have the most return visitors of any national park. The nearly 9,000 miles of park consist of one large island and 200 smaller ones that include 166 miles of hiking trails. Because the surrounding waters of Lake Superior were once treacherous for trade ships, Isle Royale is dotted with historical lighthouses. The difficult waters also made the island a hub for shipwrecks. Today, the remains of those wrecks can be visited by adventurous scuba divers. Isle Royale is considered the national park system's best-kept secret.

THE MIDWEST | STATE: MICHIGAN | **ARTIST:** DAVID DORAN

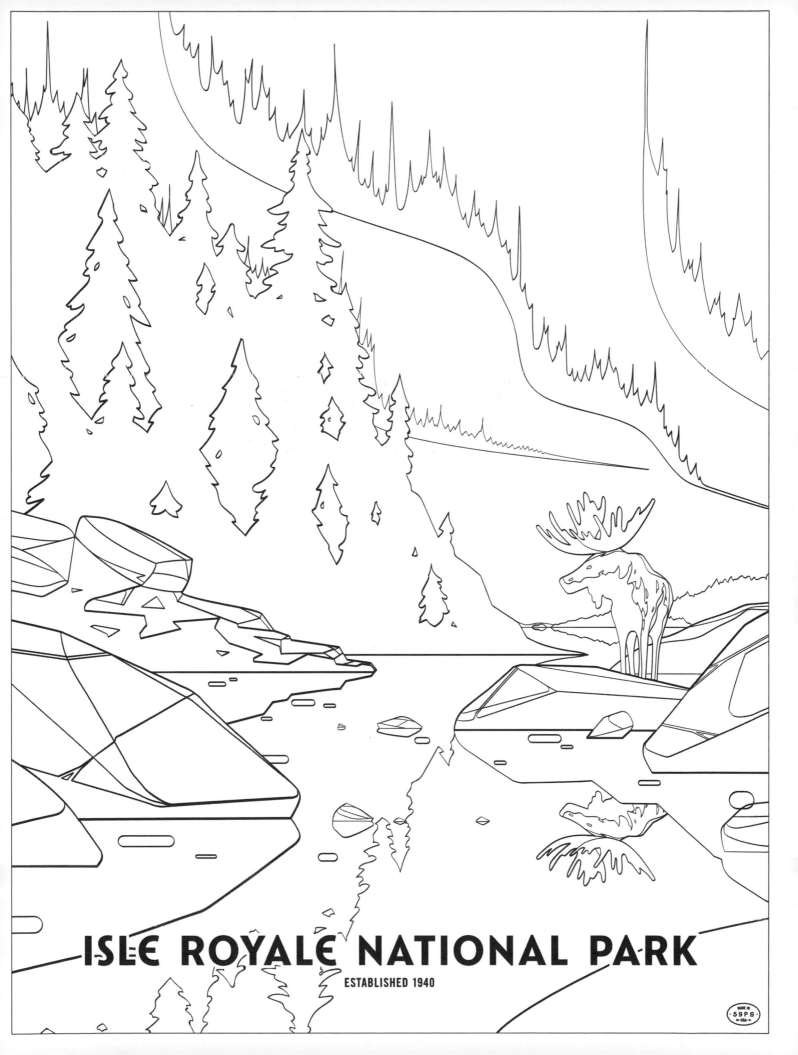

ISLE ROYALE NATIONAL PARK

ESTABLISHED 1940

INDIANA DUNES NATIONAL PARK

Encompassing 15,000 acres of land, Indian Dunes National Park includes sand dunes, prairies, wetlands, forests, swamps, bogs, marshes, and a river. The twenty-five-mile stretch of sand, lake, and greenery was known as Indiana Dunes National Lakeshore until February 2019, when it was officially upgraded to a national park. Here, the dunes stretch for miles, and some swirl up so high that they have been named. The West Beach 3-Loop Trail takes you on a three-and-a-half-mile tour of these dunes in their various stages of development, ending with a view of the Chicago skyline. Over 1,100 species of flowering plants and more than 370 bird species can be found within the park's many ecosystems.

THE MIDWEST | STATE: INDIANA | **ARTIST:** SIMON MARCHNER

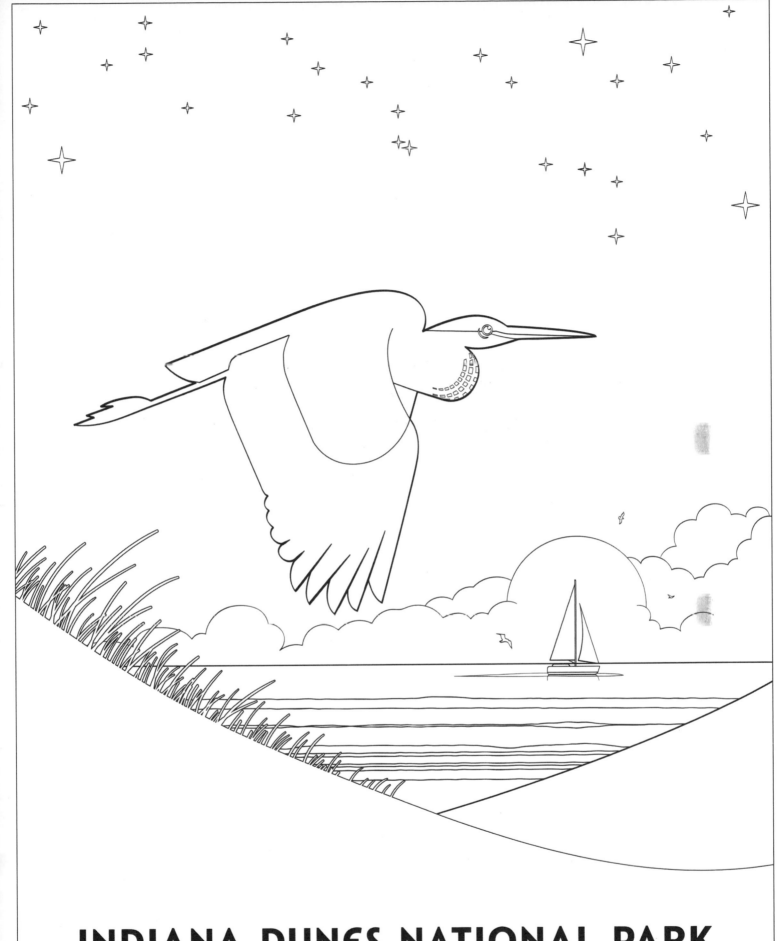

INDIANA DUNES NATIONAL PARK

ESTABLISHED 2019

GATEWAY ARCH NATIONAL PARK

Designed in 1947, Gateway Arch National Park is a 630-foot-high monument on the Mississippi River. It is an emblem of US history, a symbol of westward expansion, and a reminder of the horrors of slavery. At 90.9 acres, it is the smallest national park in the United States; upgraded from a national monument to a national park in 2017, it is also one of the newest. The park also includes the St. Louis Old Courthouse, which hosted the original Dred Scott case. The decision later became one of the inciting incidents of the Civil War. Gateway Arch reminds us of the contradictions in our founding, including both our great promise and our great capacity for evil.

THE MIDWEST | STATE: MISSOURI | **ARTIST:** STEVE SCOTT

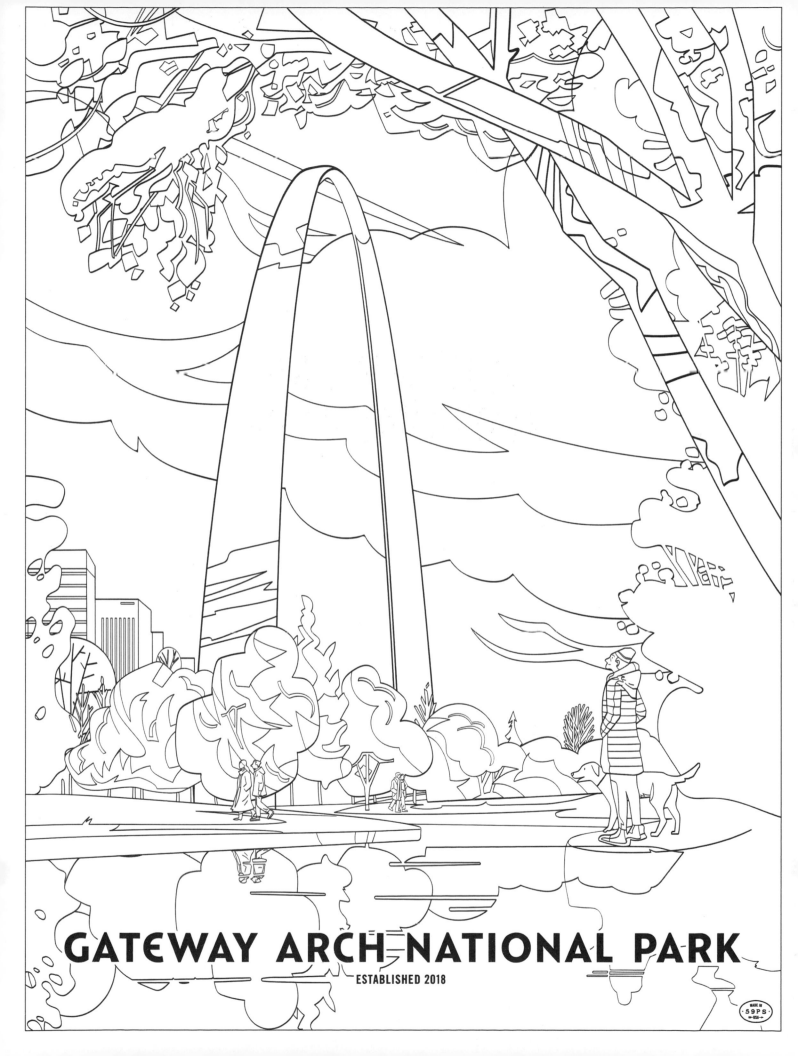

GATEWAY ARCH NATIONAL PARK

ESTABLISHED 2018

HOT SPRINGS NATIONAL PARK

Producing over 7,000 gallons of water daily, Hot Springs National Park contains 47 steaming, bubbling thermal springs. This historical park attracts around one million visitors annually. Deeded to the United States as part of the Louisiana Purchase, Hot Springs Mountain is part of the Ouachita Mountain Range. In the early nineteenth century, scientists believed the springs offered untold health benefits and people flocked to the area. The town of Hot Springs sprouted up around the influx of tourists, becoming the first "spa town" in the United States. Everyone from boxer Jack Dempsey to President Harry Truman to gangster Al Capone visited. The remnants of these health spas can still be seen on Bathhouse Row.

THE MIDWEST | STATE: ARKANSAS | **ARTIST:** TELEGRAMME PAPER CO.

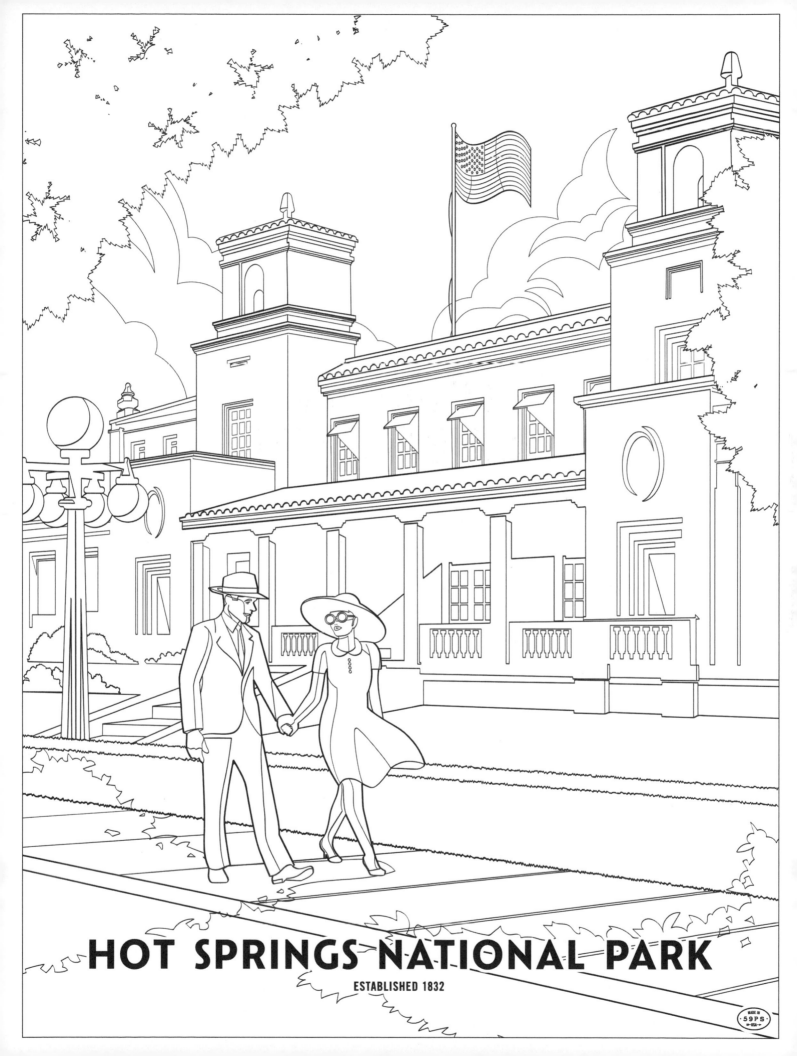

HOT SPRINGS NATIONAL PARK

ESTABLISHED 1832

VOYAGEURS
NATIONAL PARK

Made up of more than 900 islands, Voyageurs National Park features four main lakes: Rainy Lake, Kabetogama Lake, Namakan Lake, and Sand Point Lake. The lake surrounding Voyageurs is one of the country's largest habitats for beavers. During the eighteenth century, beaver fur was in high demand. The native Ojibwe hunted the beavers for their fur. Some of their most dependable customers were the French Canadian traders—the voyageurs—who came from nearby Canada in cargo canoes. These traders became the backbone of the North American fur trade. Today, the waters they frequented entertain fishermen and kayakers who come for the beautiful scenery.

THE MIDWEST | STATE: MINNESOTA | **ARTIST:** PLAID MTN

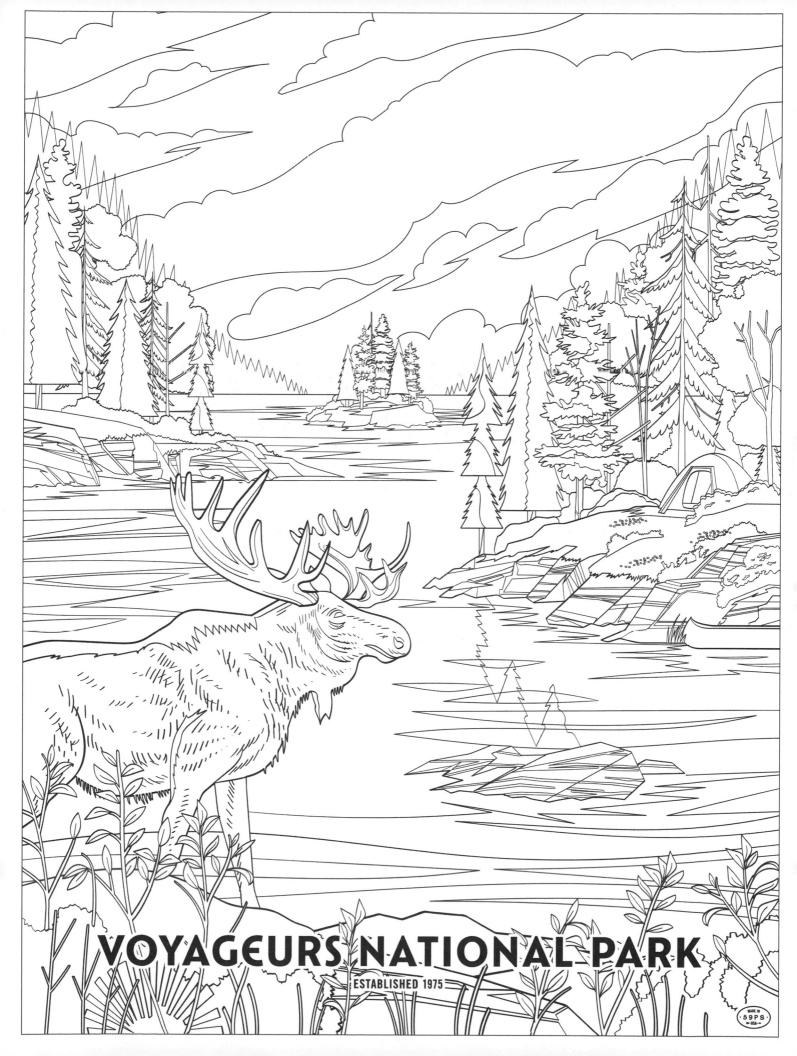

VOYAGEURS NATIONAL PARK

ESTABLISHED 1975

THEODORE ROOSEVELT NATIONAL PARK

Teeming with wildlife and lush greenery, the beauty of Theodore Roosevelt National Park inspired Roosevelt to become one of the most outspoken and powerful conservationists of all time. He loved this strip of badlands so much that he made his home here. The park is separated into three sections. Elkhorn Ranch is the most underdeveloped section of the three and contains the stone foundation that remains from Roosevelt's actual ranch. The North Unit of the park is a hub for hiking and watching wildlife. Elk, bison, and prairie dogs frolic alongside wild horses. The South Unit contains Roosevelt's fully preserved house: the Maltese Cross Cabin. Visitors can see where the former cowboy-turned-president lived.

THE MIDWEST | STATE: NORTH DAKOTA **| ARTIST:** ELLE MICHALKA

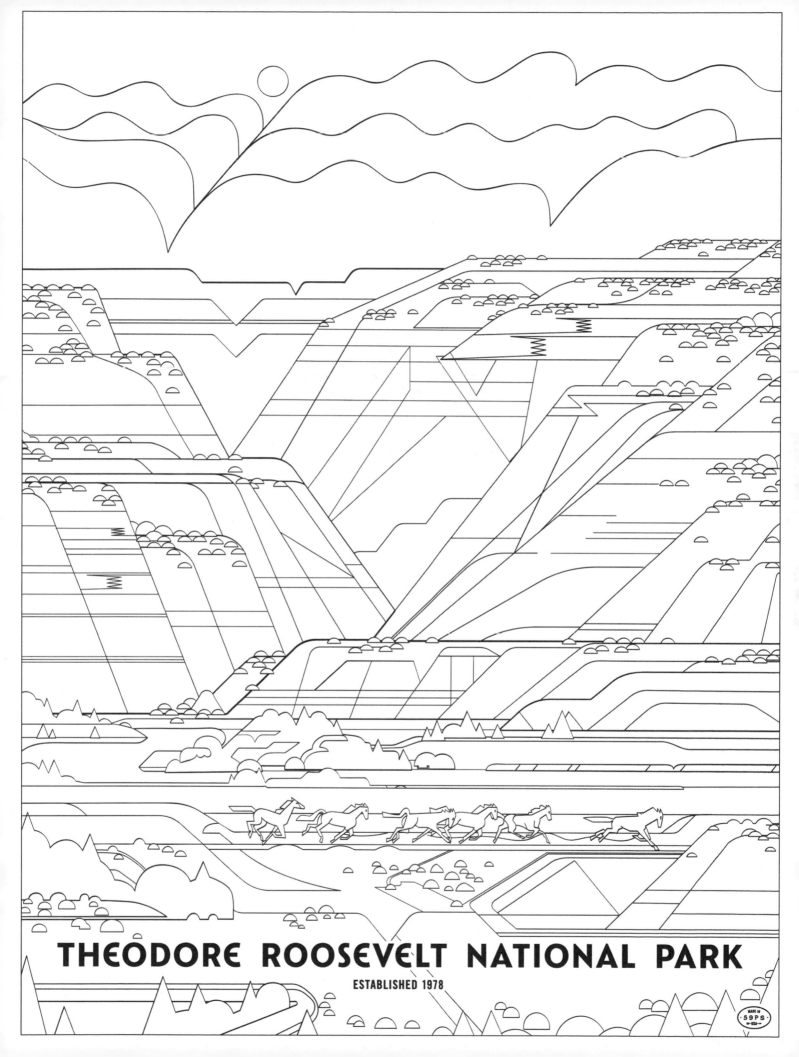

THEODORE ROOSEVELT NATIONAL PARK

ESTABLISHED 1978

BADLANDS
NATIONAL PARK

The pinnacles and eroded buttes of Badlands National Park were built up over millions of years of deposition, only to begin eroding 500,000 years ago from rivers and rainfall. The result is a spiky wonder of cartography. At the park's entrance, the flatlands are broken up by the dramatic drop known as the Big Badlands Overlook. The corrugated cliffs and gullies are marked by palettes of vivid colors. The rocks' stripy red hue is the result of iron oxidation from the burning of lignite coal. Nearby, the largest mixed-grass prairie in the entire park system hosts an array of wildlife, including vultures, butterflies, and snakes.

THE MIDWEST | STATE: SOUTH DAKOTA | **ARTIST:** CAMP NEVERNICE

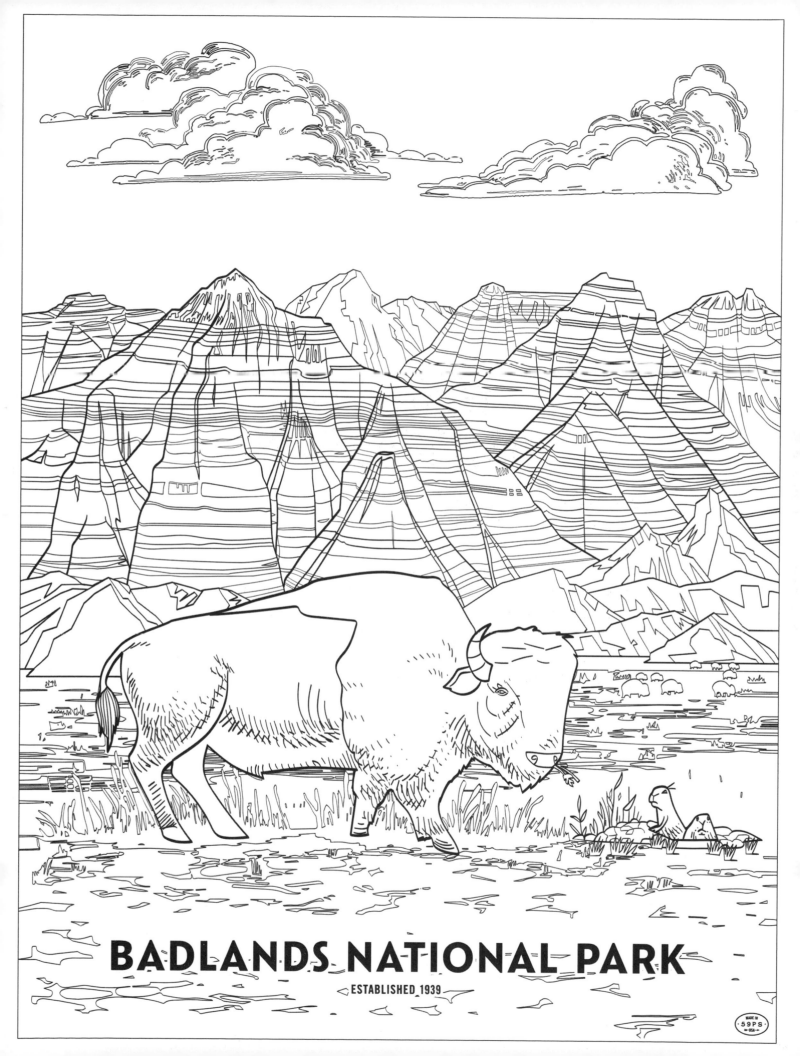

WIND CAVE NATIONAL PARK

Considered sacred by the Lakota Sioux, Wind Cave National Park contains over 149 miles of complex mazelike passageways. Settlers may not have even discovered it if not for the wind whistling through the passageways. One day, two hunters noticed that the deer they were hunting was distracted by a faint whistling sound. The sound appeared to be coming from a small hole in the ground. When one of the hunters knelt close to the hole, a gust of wind erupted from the ground and knocked off his hat. This marked the discovery of one of the oldest caves in the country. The cave is said to "breathe" because atmospheric pressure can cause the cave's holes to expel sporadic gusts of air.

THE MIDWEST | STATE: SOUTH DAKOTA **| ARTIST:** JONATHAN BARTLETT

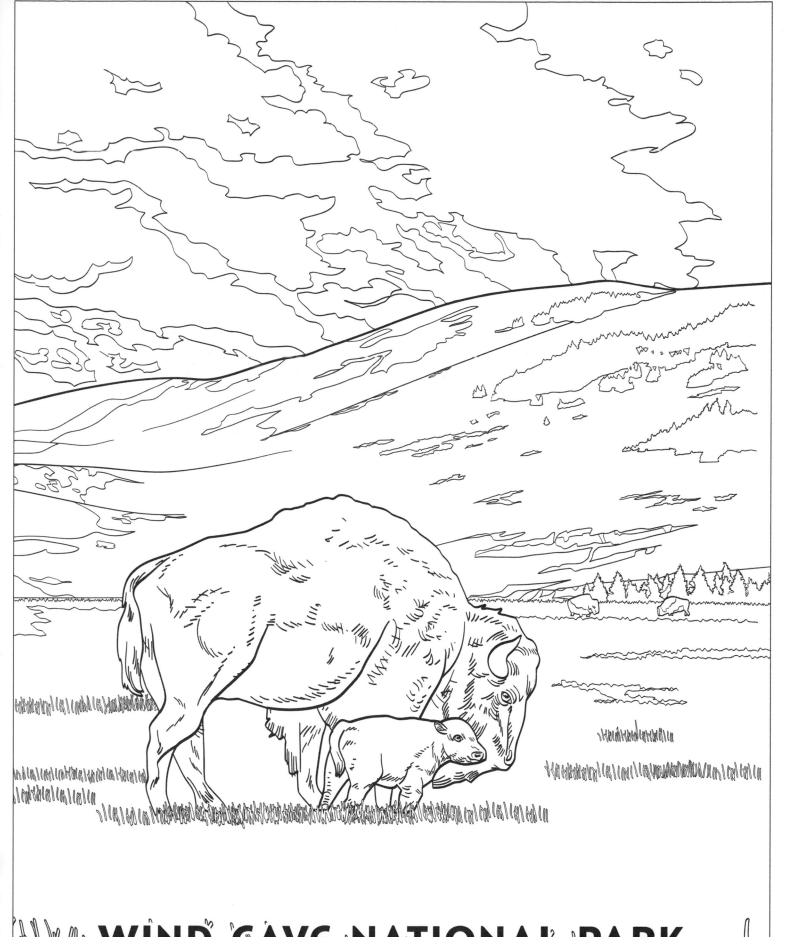

WIND CAVE NATIONAL PARK

ESTABLISHED 1903

GUADALUPE MOUNTAINS NATIONAL PARK

What seems at first an endless desert is revealed to be a great myriad of ecosystems in Guadalupe Mountains National Park, from verdant forests to heaping sand dunes. The tallest peaks in the state are here in the Chihuahuan Desert. Guadalupe Peak, formed from the remnants of an underwater reef, juts up into the clouds, reaching nearly 9,000 feet. The 8,085-foot-high El Capitan, constructed primarily of long-desiccated sponges and algae, is equally breathtaking. Eccentric rock formations like the Devil's Hall consist of a natural rock staircase that leads to a tight hallway. The salt flats are desolate, and desert shrubs slouch in the dry heat. Fortunately, there's an oasis around every corner. Moisture from the mountains collects in natural streams and springs.

THE SOUTHWEST | STATE: TEXAS | **ARTIST:** MATT TAYLOR

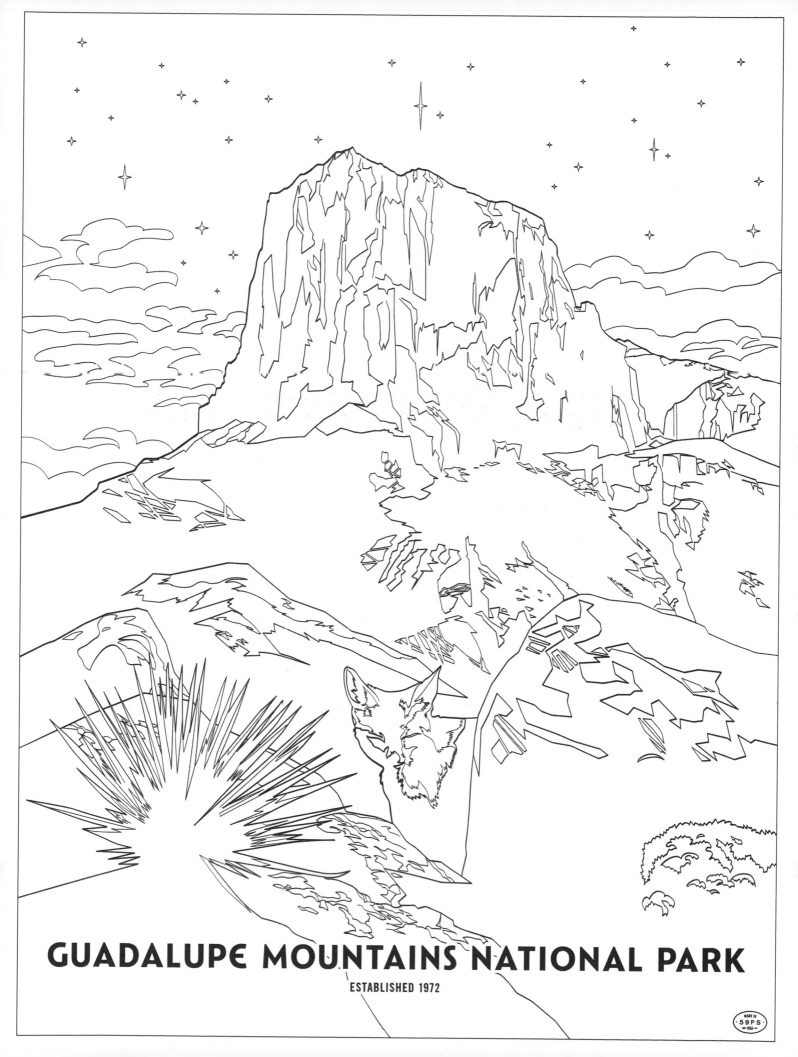

GUADALUPE MOUNTAINS NATIONAL PARK

ESTABLISHED 1972

BIG BEND NATIONAL PARK

Named for its location at the bend in the Rio Grande, the huge landmass that makes up Big Bend National Park stretches 800,000 acres. Over millions of years, the Rio Grande's mighty waters carved their way through the limestone walls of these towering canyons. Separated mainly into three districts—the river, the mountains, and the desert—Big Bend is a living temple dedicated to the natural power of the elements. Hike the valleys of Big Bend with the Chisos Mountain Range looming in the background and take in rock formations varied in size, shape, and appearance. Canoe along the Rio Grande and see red-eared slider turtles tottering along in the shadow of the Santa Elena Canyon.

THE SOUTHWEST | STATE: TEXAS | **ARTIST:** BRAVE THE WOODS

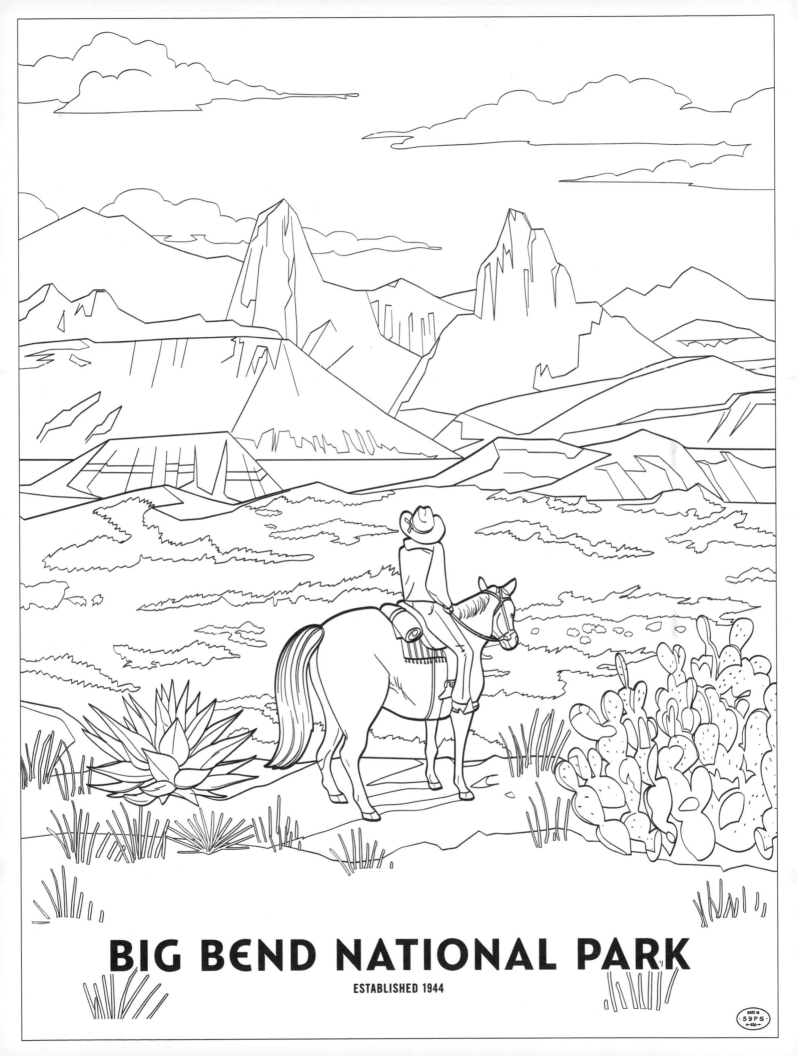

BIG BEND NATIONAL PARK

ESTABLISHED 1944

GRAND CANYON NATIONAL PARK

One of the Seven Wonders of the World, Grand Canyon National Park is a nearly two-million-square-mile gorge carved out by the Colorado River's incessant rush. The view from the canyon's famous South Rim offers sweeping landscapes and panoramic vistas. The even higher North Rim offers an enrapturing look at the vivid palette of the upper cliffs. Mule rides into the canyon's depths reveal thriving shrubs, pine forests, and grasslands. Inside the depths of this red rock coliseum, the landscape is always shifting; jutting cliffs give way to limestone deposits before being suddenly broken up by crashing waterfalls. From small native villages to rushing tributaries, there's no dull spot here.

THE SOUTHWEST | STATE: ARIZONA **| ARTIST:** DKNG STUDIOS

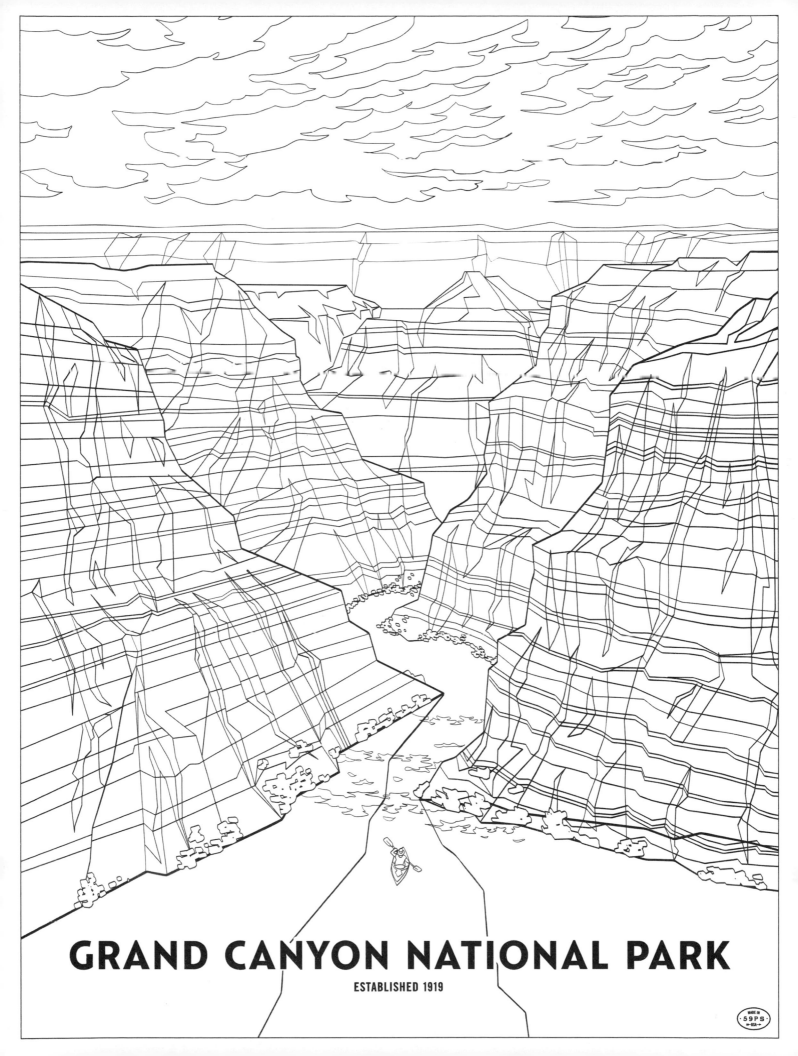

GRAND CANYON NATIONAL PARK

ESTABLISHED 1919

PETRIFIED FOREST NATIONAL PARK

Millions of years ago, Petrified Forest National Park was a swamp; now, all 220,000 acres of the forest are above 5,000 feet. Logs that fell into the swamp absorbed the mud and minerals from within and eons of natural fossilization occurred. The interior of the wood resembles a kaleidoscope, with amethyst, jasper, and quartz swirling like tie-dye. The Crystal Forest is crowded with logs that contain clear quartz and purple amethyst crystals. Agate House, a hut made from petrified wood, has been fully restored and is bursting with reds and yellows. When visiting, Albert Einstein repeatedly asked the same question: "How?" Nothing feels of this world in this magical park.

THE SOUTHWEST | STATE: ARIZONA | **ARTIST:** KEVIN HONG

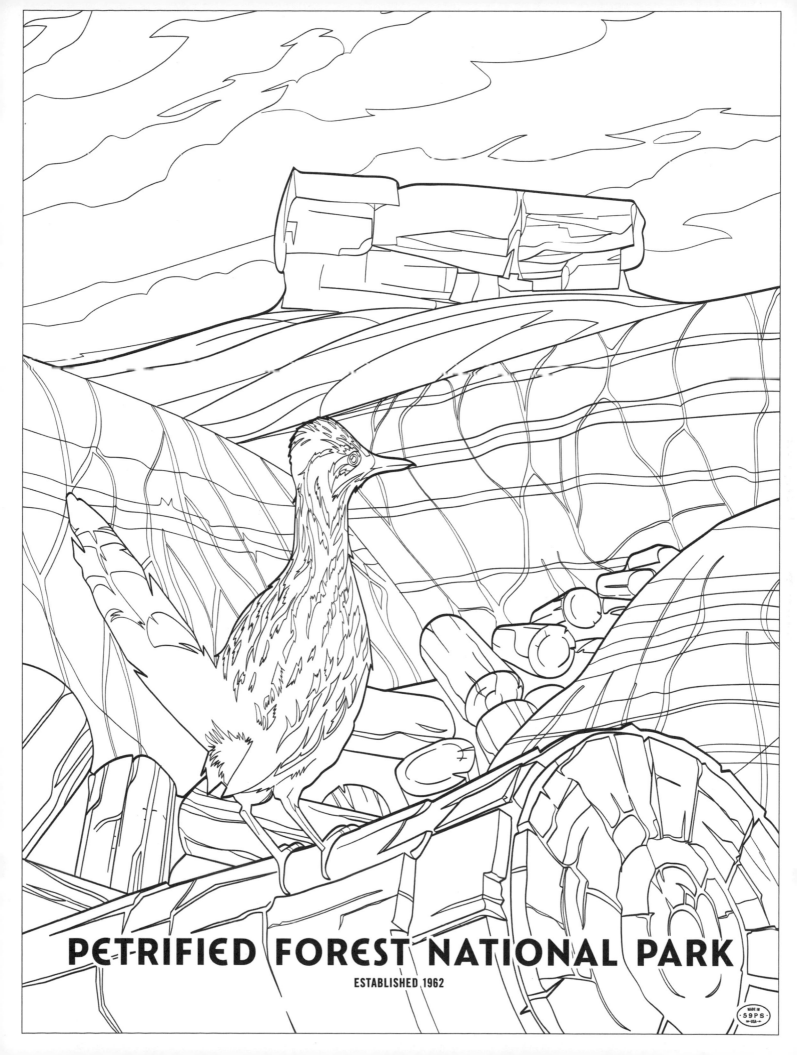

PETRIFIED FOREST NATIONAL PARK

ESTABLISHED 1962

SAGUARO NATIONAL PARK

The only place in the world where the eponymous saguaro grows, Saguaro National Park's 91,000 acres of mountains and desert are protected to preserve this iconic cactus. Only the strong and resolute survive the desert's extremes. Saguaro cacti are 80 to 90 percent water and can grow up to fifty feet tall and live for up to 150 years. The park also features the world's smallest owl, the elf owl. Humans have also left their mark on the desert landscape. The short cliffs of Signal Hill in the Tucson Mountains feature geometric petroglyphs from the fourteenth and fifteenth centuries. As the sun beats down on the desert, the saguaros stand tall, defiant in their ability to survive.

THE SOUTHWEST | STATE: ARIZONA **| ARTIST:** NICK SLATER

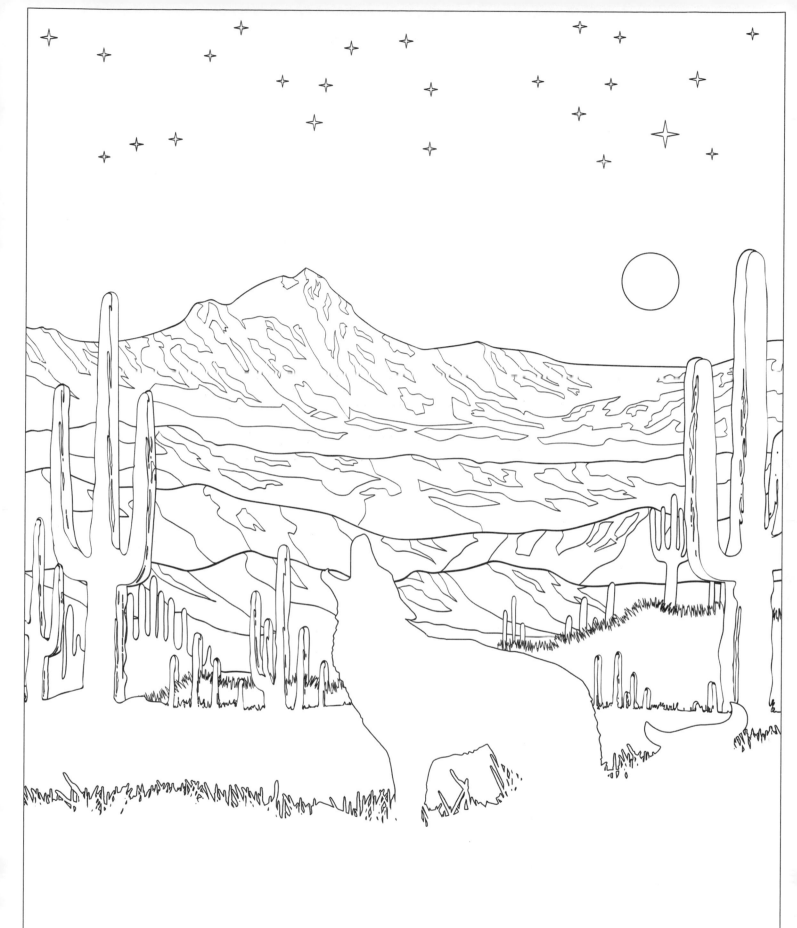

SAGUARO NATIONAL PARK

ESTABLISHED 1994

CARLSBAD CAVERNS NATIONAL PARK

Featuring 120 natural caves, numerous canyons, and one of the world's best-preserved fossilized reefs, Carlsbad Caverns National Park is an underground treasure trove. The Big Room is a 4,000-foot-long, 625-foot-wide limestone gallery of rare geological phenomena. The cavern was described by actor Will Rogers as "the Grand Canyon with a roof over it." A craggy passageway dubbed the "Bat Cave" is home to most of the area's bat population. Mystery Room is a small section of the cave known for an unidentifiable noise that cannot be heard anywhere else in the park. Each step inside these caves holds the possibility of discovery, and new sections are consistently unearthed by scientists and adventurers.

THE SOUTHWEST | STATE: NEW MEXICO **| ARTIST:** KILIAN ENG

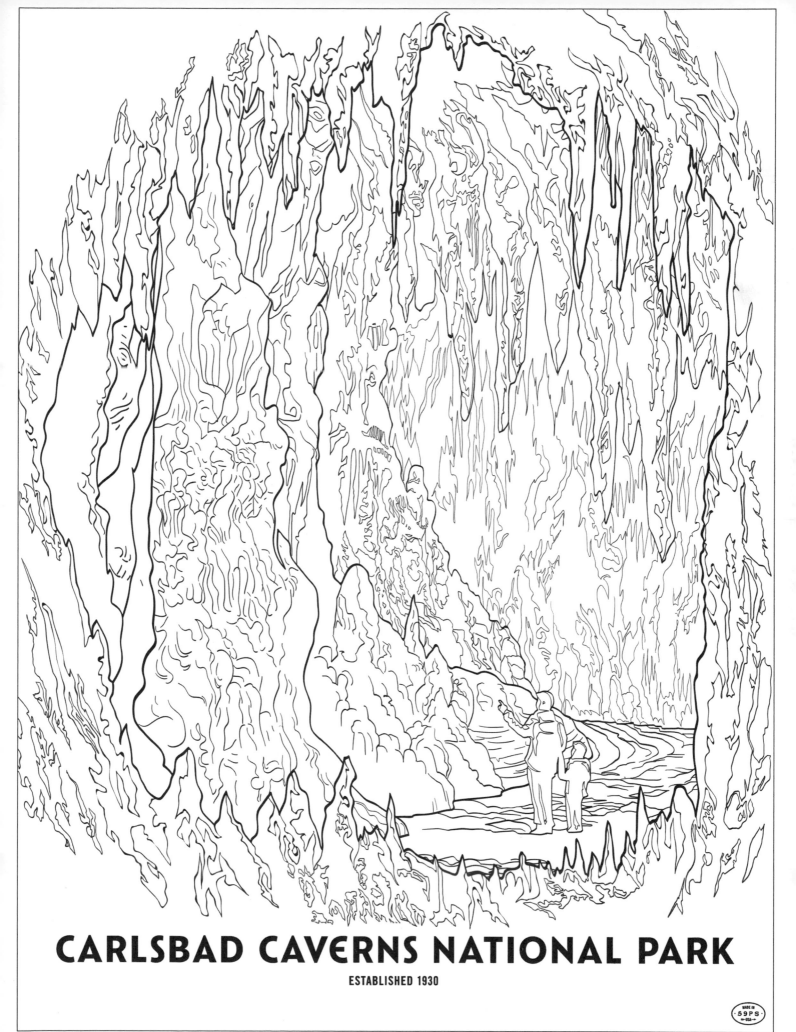

CARLSBAD CAVERNS NATIONAL PARK

ESTABLISHED 1930

MADE IN
59 PS
USA

WHITE SANDS NATIONAL PARK

Featuring the world's largest gypsum dune field, White Sands National Park encompasses more than 275 square miles of powdery dunes that stretch up to sixty feet tall. These blinding white dunes are a marvel of nature so foreign to the human eye that visitors regularly get lost while exploring them. Large gypsum dune fields are uncommon because gypsum sand is water soluble and usually dissolved or washed away by rainwater. White Sands' location in the isolated Tularosa Basin protects the dunes from rain. Succulents, cacti, and yucca are throughout the park, along with myriad species of rodents and reptiles. Perhaps most surprising of all, ninety-three African oryx reside here, their horns glinting in the desert sun.

THE SOUTHWEST | STATE: NEW MEXICO **| ARTIST:** MARIANNA TOMASELLI

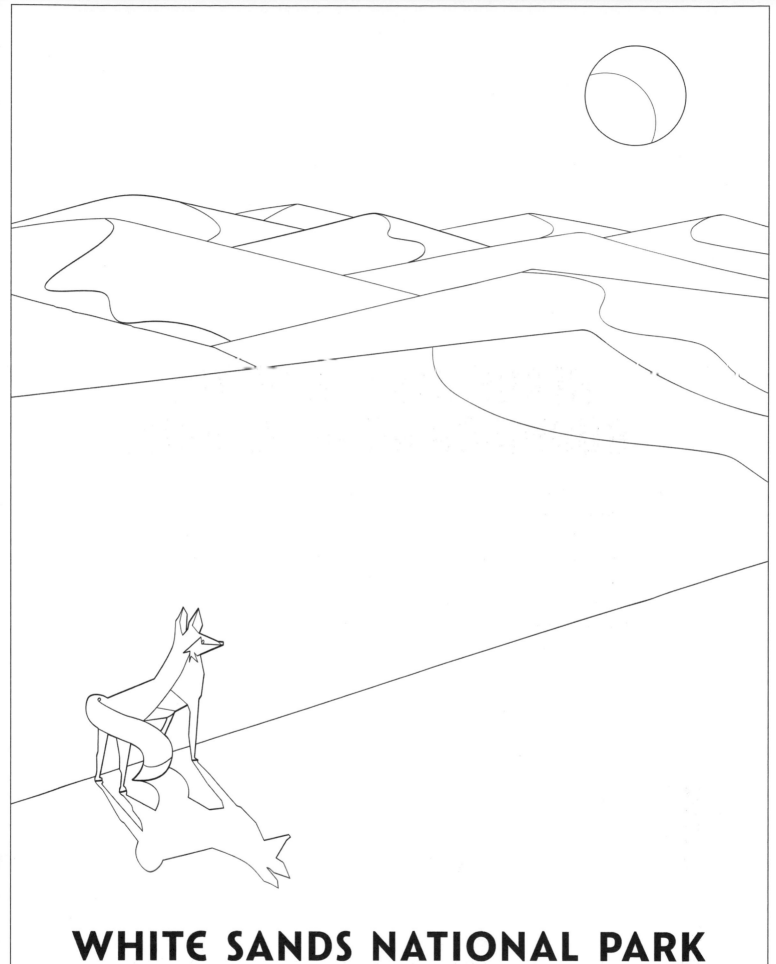

WHITE SANDS NATIONAL PARK

ESTABLISHED 2019

BLACK CANYON OF THE GUNNISON NATIONAL PARK

The colossal 2,000-foot-deep Black Canyon in Black Canyon of the Gunnison National Park is the deepest, narrowest, and darkest canyon in the country. The Gunnison River slopes thirty-four feet per mile through the canyon, making it one of the steepest rivers in the nation. The flow of the Gunnison is so mighty that humans couldn't explore the bottom of Black Canyon until the early twentieth century, after they built the Gunnison Tunnel and Diversion Dam to slow the speed. Every year that the Gunnison rushes along the Black Canyon walls, a human hair's width of rock is eroded.

THE WEST | STATE: COLORADO | **ARTIST:** JEFF LANGEVIN

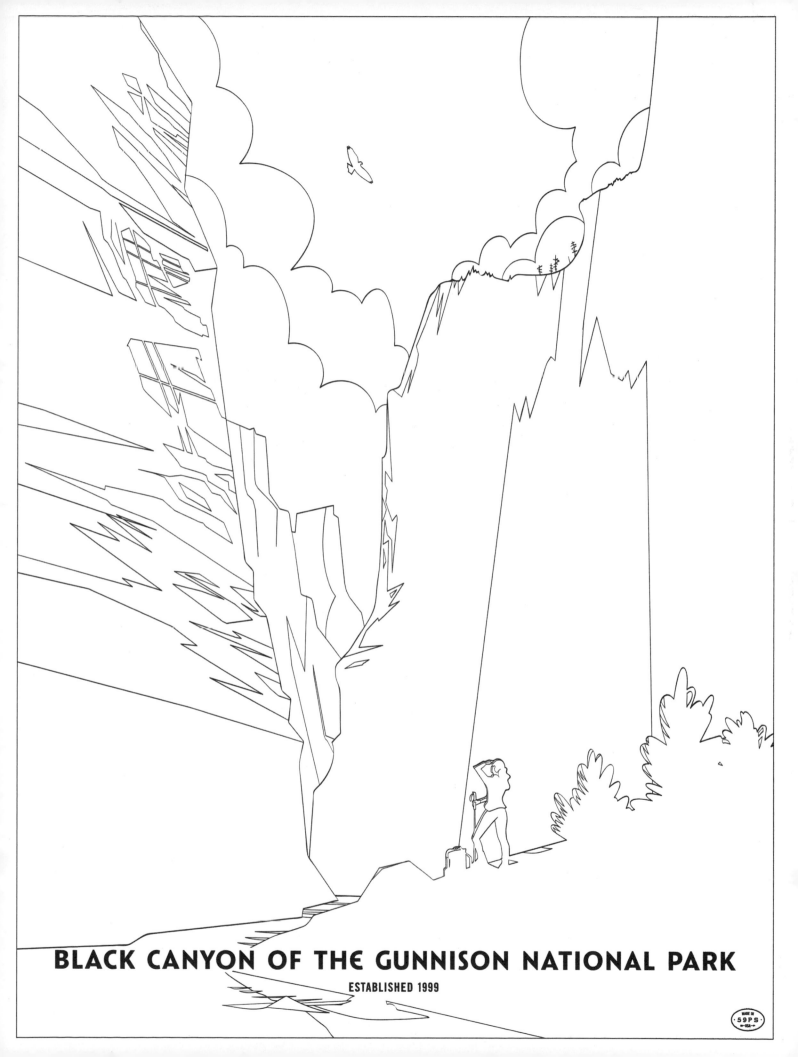

BLACK CANYON OF THE GUNNISON NATIONAL PARK

ESTABLISHED 1999

BRYCE CANYON NATIONAL PARK

The world's highest concentration of hoodoos—mushroom-like rock formations—can be found in Bryce Canyon National Park. The 35,835-acre park also features a collection of natural amphitheaters, the largest of which, Bryce Amphitheater, measures twelve miles long and three miles wide. The eighteen-mile scenic drive to Rainbow Point offers the perfect opportunity to see a vast majority of the park at once, including thirteen possible viewpoints. One of these viewpoints, Natural Bridge, looks like a huge flat-topped cliff with a hole punched in the middle. At Rainbow Point, you can look out from the southern end of the park and soak up Bryce Canyon's unusual beauty.

THE WEST | STATE: UTAH | **ARTIST:** CLAIRE HUMMEL

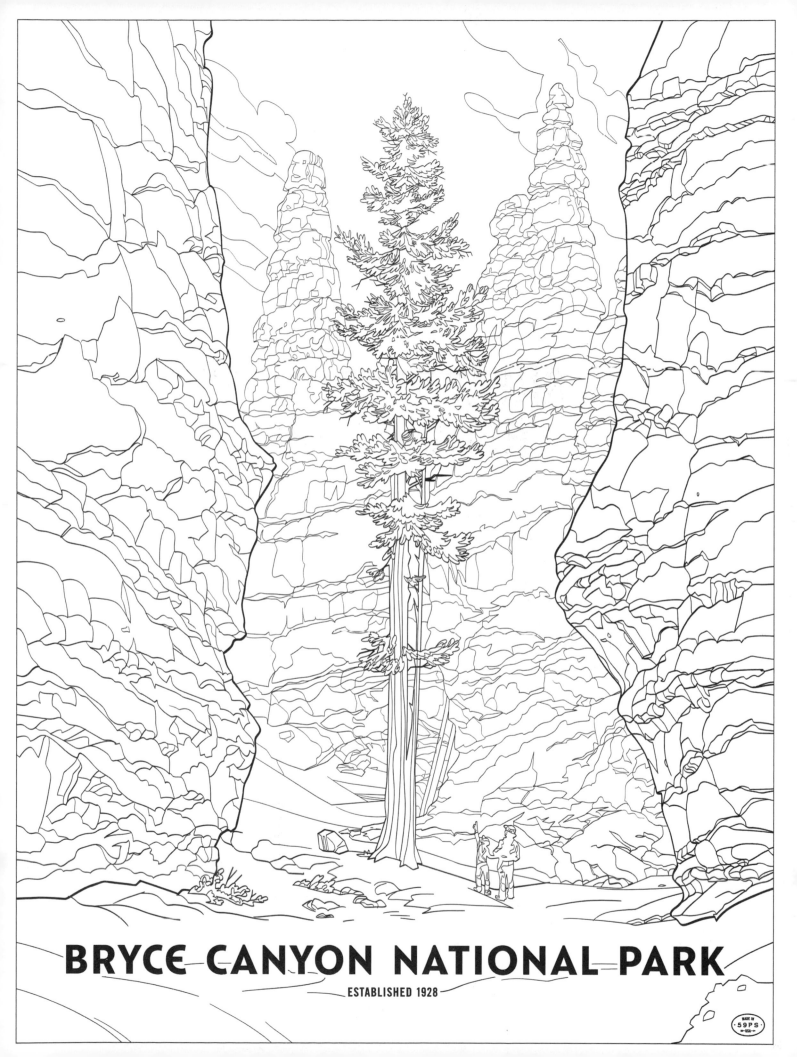

BRYCE CANYON NATIONAL PARK

ESTABLISHED 1928

GREAT SAND DUNES NATIONAL PARK

Over 30 square miles of sand dunes can be found at Great Sand Dunes National Park, some soaring as high as 750 feet. The winds that blaze through the peaks of the Rockies mold these earth castles and earth pyramids one grain at a time. The dunes constantly shift and reshape. Melting snow high in the mountains forms a lake, cascades through meadows and forests, and ultimately lands in Medano Creek, causing natural waves that form every thirty seconds. The juxtaposition of tundra with rich forests and warm wetlands creates a profusion of flora and fauna in the park. Like the soaring heights and swooping lows of the dunes, Great Sand Dunes National Park is a place where the earth changes right before your eyes.

THE WEST | STATE: COLORADO | **ARTIST:** NICOLAS DELORT

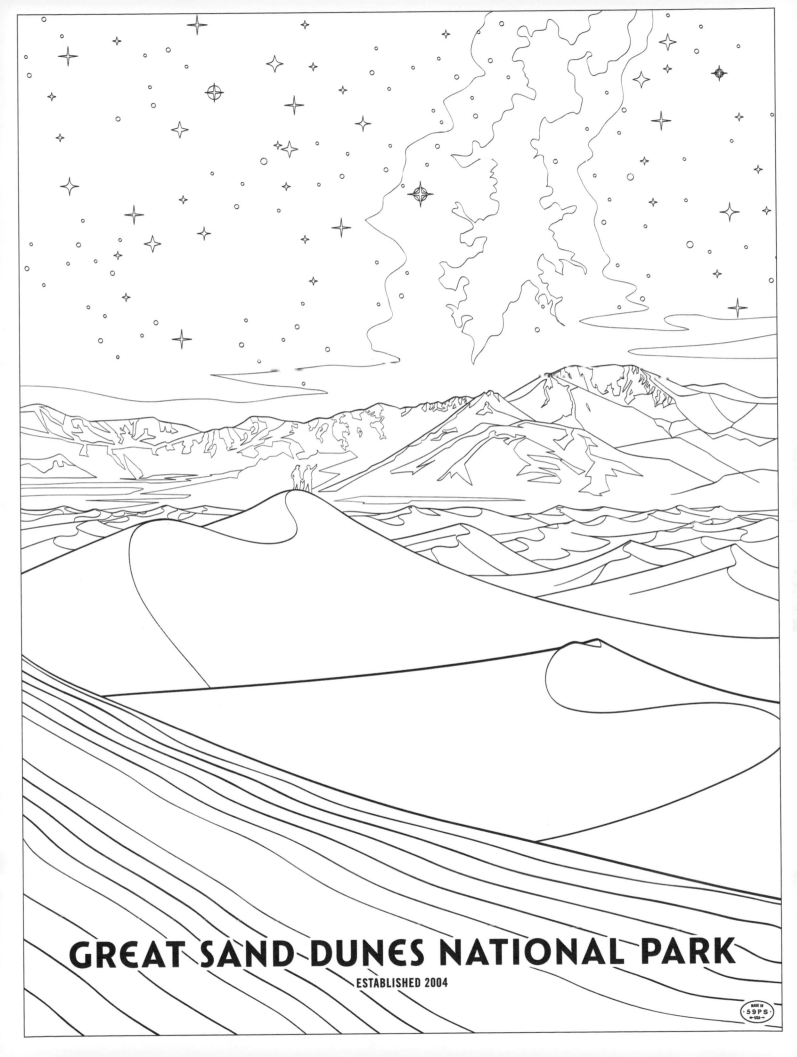

GREAT SAND DUNES NATIONAL PARK

ESTABLISHED 2004

MESA VERDE NATIONAL PARK

With over 600 cliff dwellings left behind by Ancestral Puebloans, Mesa Verde National Park is one of the best preserved archeological sites on Earth. This 52,485-acre park is uniquely located at the Four Corners of the United States—where Arizona meets Utah, New Mexico, and Colorado. Entire preserved villages are carved into these cliffs. There are small dwellings dug into the ground called pit houses, round meeting rooms called kivas, and multiroom stacked row houses called pueblos. Rudimentary irrigation systems and houses of worship can also be found on the mesa. The inhabitants of these villages disappeared mysteriously, but they left behind a wealth of clues that help us understand their ancient civilization, and their innovative dwellings still inspire us to this day.

THE WEST | STATE: COLORADO | **ARTIST:** CLAIRE HUMMEL

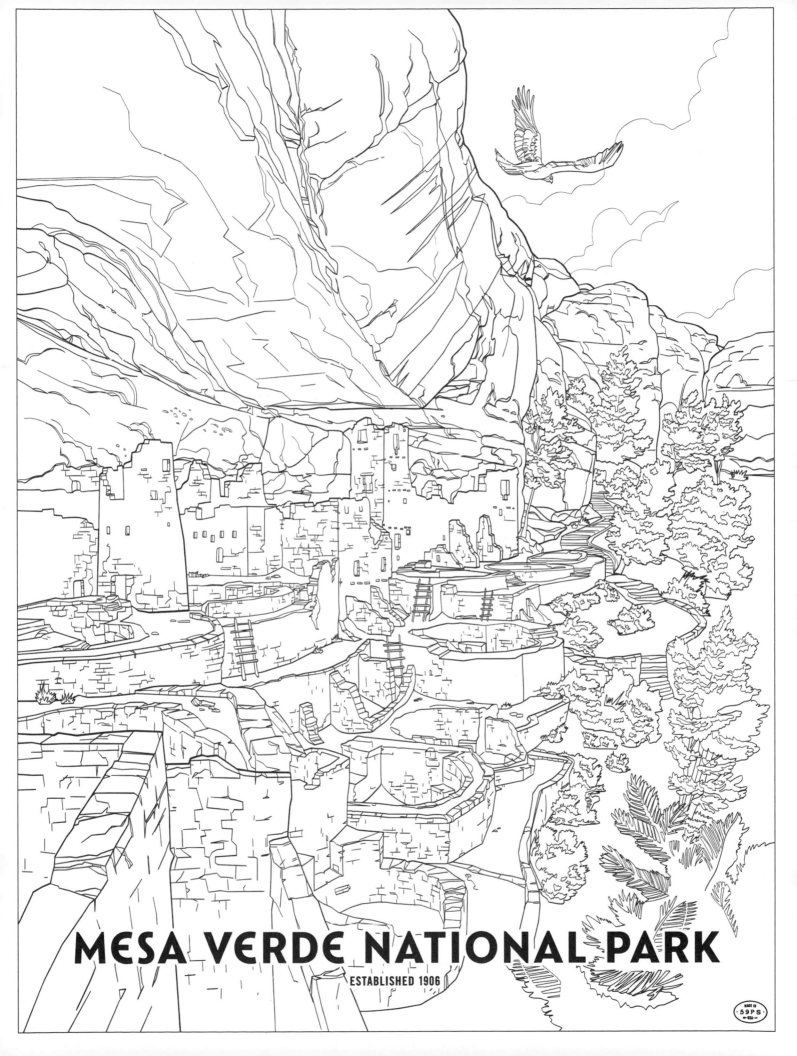

MESA VERDE NATIONAL PARK

ESTABLISHED 1906

ROCKY MOUNTAIN NATIONAL PARK

Containing some of the most treacherous paths that settlers braved to get West, Rocky Mountain National Park spans along the Continental Divide. Bighorn sheep graze in the valleys, black bears haunt the backcountry's caves, boreal owls perch in the cottonwood trees, and trout swim in Dream Lake. During summer and fall, the Rocky Mountain elk own the park. While 600 to 800 elk are present during winter, their numbers increase to 3,200 during fall and summer. In the fall, the male bull elk partakes in the cacophony of grunts, shrieks, and screeches known as bugling. The sound of the bull elk bugling for a mate is often called "otherworldly," an adjective that perfectly describes the beauty found here.

THE WEST | STATE: COLORADO | **ARTIST:** RORY KURTZ

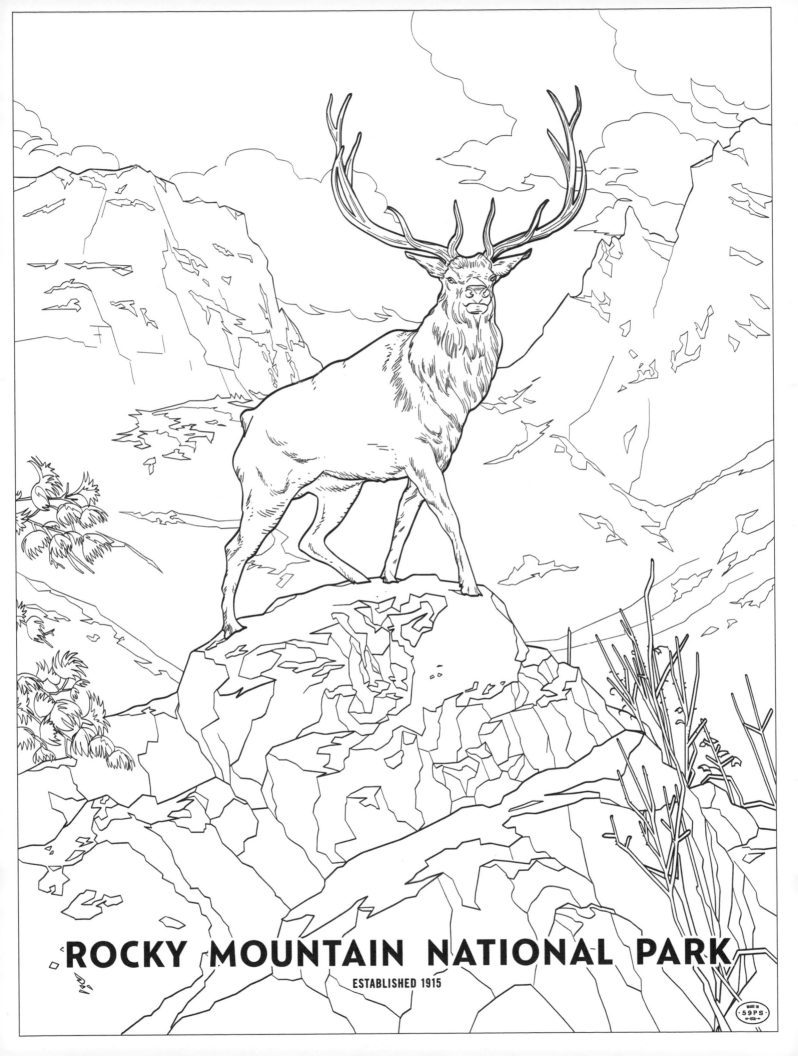

ROCKY MOUNTAIN NATIONAL PARK

ESTABLISHED 1915

GRAND TETON NATIONAL PARK

Hundreds of black bears and grizzly bears call Grand Teton National Park home, along with elk, pronghorns, beavers, moose, and bison. The park has a mountain range that shoots up 7,000 feet high straight from the lowlands of the Jackson Hole valley. There is nowhere this side of Scandinavia to find fresh water as blue as the lakes of Grand Teton. Delta Lake's turquoise color results from rock flour fed into the lake by the surrounding Glacier Gulch. The Teton mountain range, considered the youngest of the Rocky Mountains, and all that surrounds it look almost too immaculate to be real. The snow-dusted mountain caps are reflected perfectly by the mirror-like lakes below.

THE WEST | STATE: WYOMING **| ARTIST:** KIM SMITH

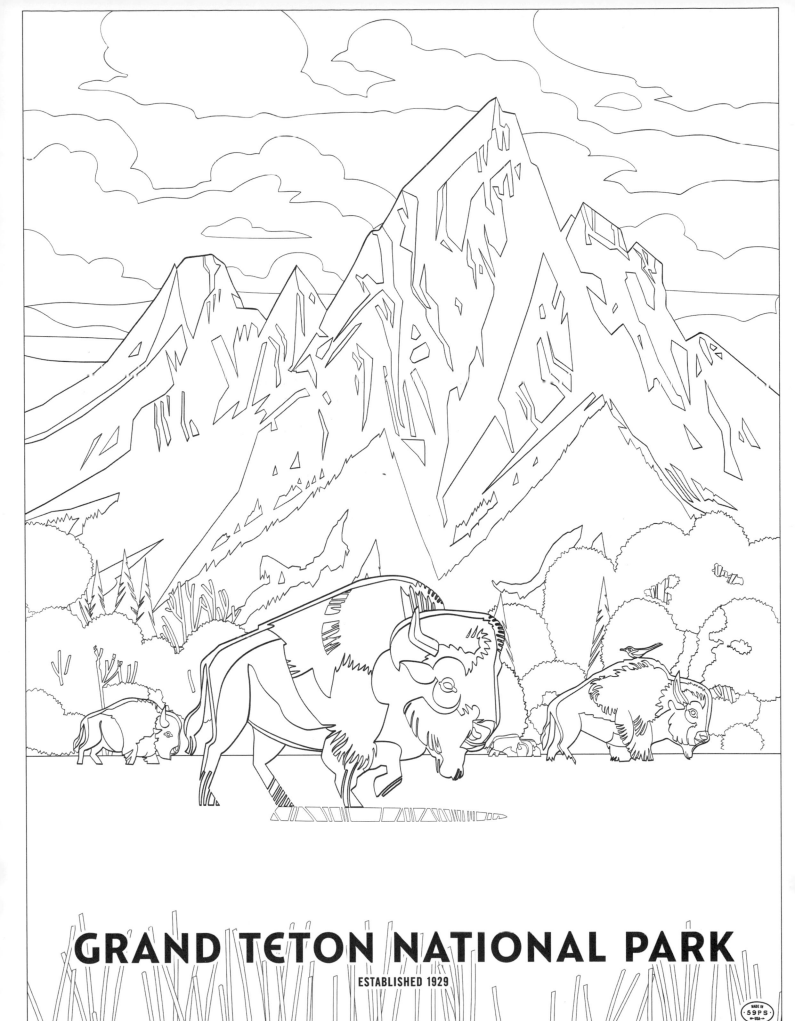

GRAND TETON NATIONAL PARK

ESTABLISHED 1929

YELLOWSTONE NATIONAL PARK

You can find lakes, rivers, canyons, mountain ranges, forests, wildlife, world-famous geothermal features, and even a volcano in Yellowstone National Park. It has been 70,000 years since the Yellowstone Caldera, sometimes called the Yellowstone Supervolcano, last produced lava. Instead, it currently expels steam from a series of geothermal vents throughout the park. One vent, Old Faithful, has erupted every forty-four minutes to two hours since the year 2000. Mammoth Hot Springs is a collection of over fifty hot springs. At Boiling River, the hot springs mix with colder river water and visitors can safely take a dip. Another part of the park, Lamar Valley, has been dubbed America's Serengeti; this grassy landscape is home to wolves, grizzly bears, bald eagles, and bison.

THE WEST | STATE: WYOMING , MONTANA, AND IDAHO | **ARTIST:** BRAVE THE WOODS

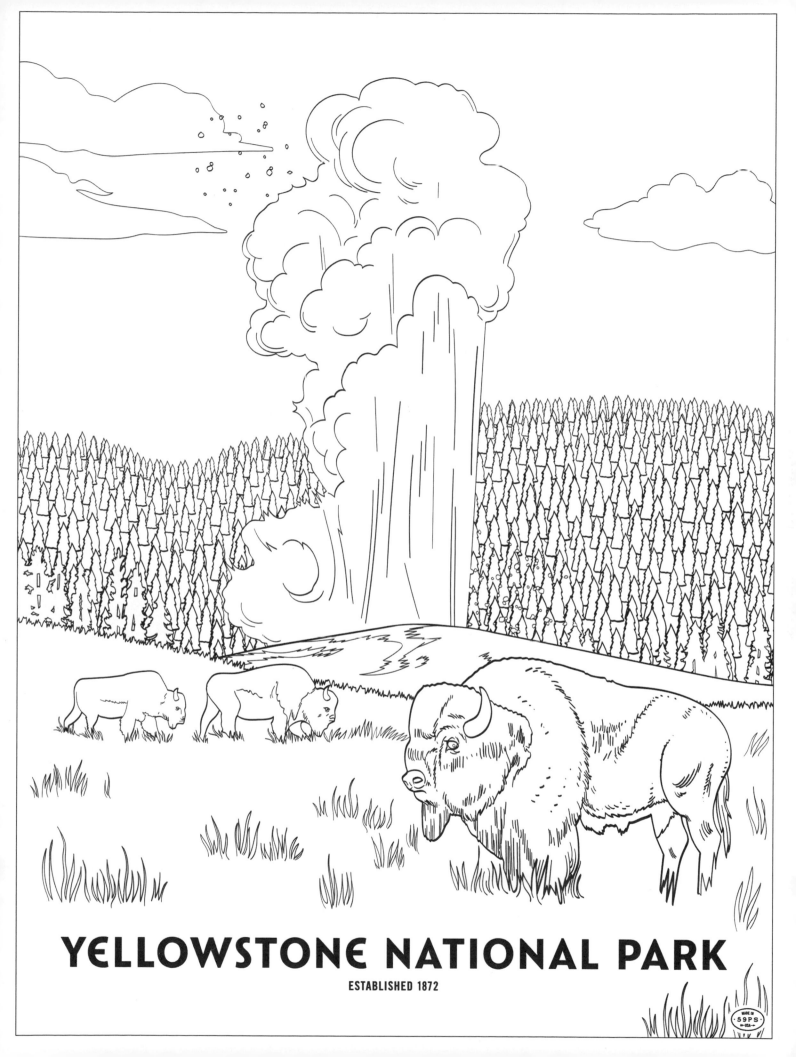

YELLOWSTONE NATIONAL PARK

ESTABLISHED 1872

GLACIER NATIONAL PARK

There are jagged mountain peaks, alpine glaciers, and gushing waterfalls in Glacier National Park. Moose, grizzlies, and mountain goats wander the mountains alongside rarer species like Canadian lynx and wolverines. Hundreds of grizzlies and black bears call these mountains home; however, it's the eponymous glaciers of the park that visitors find most astounding. These massive, swirling ice temples are as rare as they are precious. There were once up to 150 in the park, but they have since dwindled down to fewer than thirty. The melting glaciers are an important reminder of the fleeting nature of our nation's most awe-inspiring beauty.

THE WEST | STATE: MONTANA **| ARTIST:** LAURENT DURIEUX

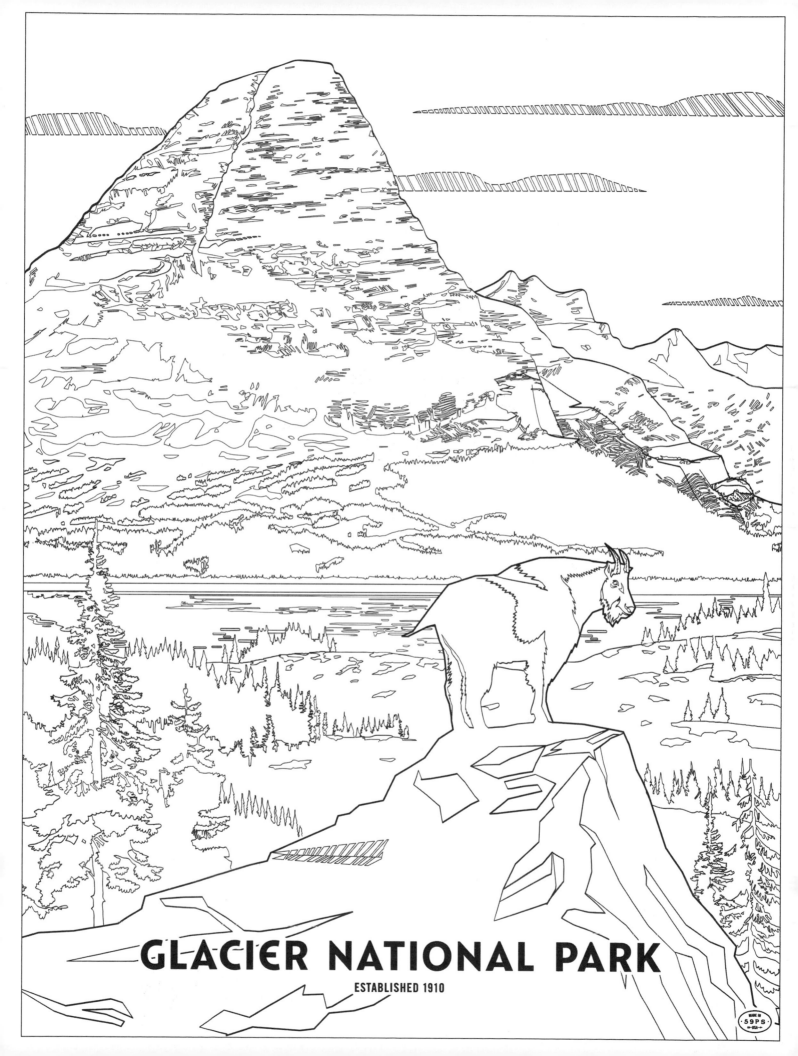

GLACIER NATIONAL PARK

ESTABLISHED 1910

DEATH VALLEY NATIONAL PARK

Despite its name, there is plenty of life in Death Valley, the country's lowest, driest, and hottest national park. In the Great Basin and Mojave Desert, canyons, valleys, and mountains tower over sand dunes, salt flats, and badlands. Within this enormous park are some of the most stunning marvels of lowland desert that the natural world can offer. Ubehebe Crater is a 600-foot-deep maar volcano of billowing slate-gray ash. The area known as Racetrack Playa contains mysterious moving stones that leave trails behind them. Death Valley is America's darkest shadow, the place where the night sky shines its blackest.

THE WEST | STATE: CALIFORNIA, NEVADA | **ARTIST:** CRISTIAN ERES

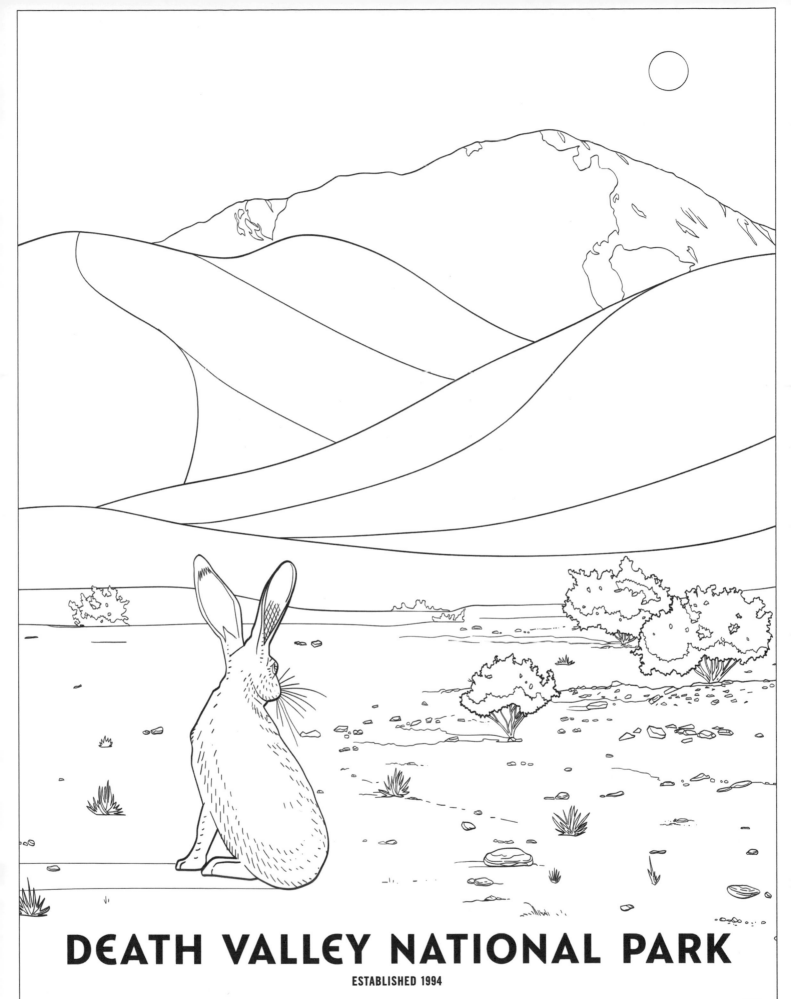

DEATH VALLEY NATIONAL PARK

ESTABLISHED 1994

JOSHUA TREE NATIONAL PARK

Walk upon the splintered sands of the Mojave and take in the splendor of Joshua Tree National Park's against-all-odds ecosystem. The park is most famous for the eponymous Joshua Tree, also known as the Yucca brevifolia. Thousands of this tree are in Queen Valley and Lost Horse Valley, the park's grassland areas. Early Mormon settlers named the tree Joshua, believing its thick and stubby branches resembled the arms of the biblical figure as he guided his people to the land of milk and honey. A certified Dark Sky Park, Joshua Tree is far enough from the light pollution of nearby cities to enjoy some of the best stargazing in the country.

THE WEST | STATE: CALIFORNIA | **ARTIST:** LITTLE FRIENDS OF PRINTMAKING

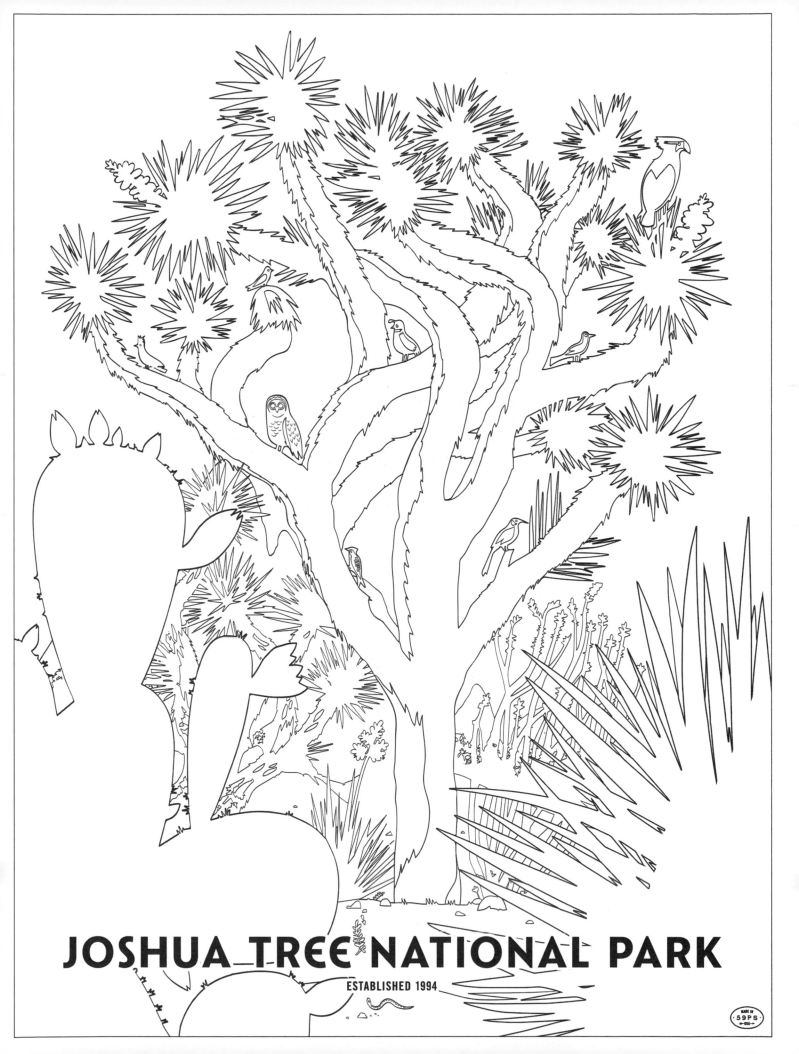

JOSHUA TREE NATIONAL PARK

ESTABLISHED 1994

KINGS CANYON NATIONAL PARK

Located in the southern Sierra Nevada Mountains, Kings Canyon National Park comprises an intricate network of valleys, forests, and canyons. It offers diverse terrain, including some of the steepest peaks in the country. The Sierra Crest mountain range marks the eastern boundary of the park. From here, the Middle Fork Kings River carves its way through the southern portion of the park, creating the mile-deep canyon for which the park is named. The elevation changes create whitewater rapids and waterfalls along the rivers of the Sierra. Nearby sequoia forests are home to some of the tallest living things on the planet.

THE WEST | STATE: CALIFORNIA | **ARTIST:** ERIC TAN

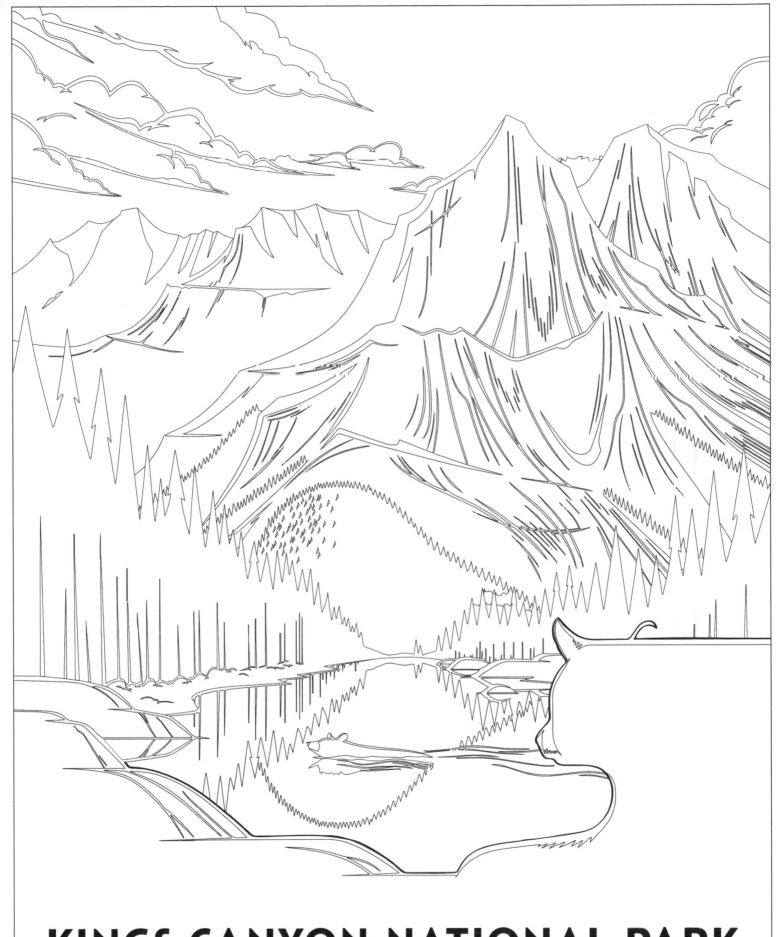

KINGS CANYON NATIONAL PARK

ESTABLISHED 1940

LASSEN VOLCANIC NATIONAL PARK

With elevations ranging from 5,300 feet to 10,000 feet, Lassen Volcanic National Park boasts every type of volcano: plug dome, cinder cone, shield, and strata. This was once the most active volcanic region in America; today, only Lassen Peak, the world's largest plug dome volcano, is still active. The geothermal features throughout the park are a reminder of the lava that once covered the area. Pools of red, yellow, orange, and green are formed from broken-down sulfuric acid. Elsewhere, the park includes over 27,000 acres of old-growth forests. Grassy meadows teeming with wildlife surround the beautiful, deep blue Manzanita Lake.

THE WEST | STATE: CALIFORNIA | **ARTIST:** AARON POWERS

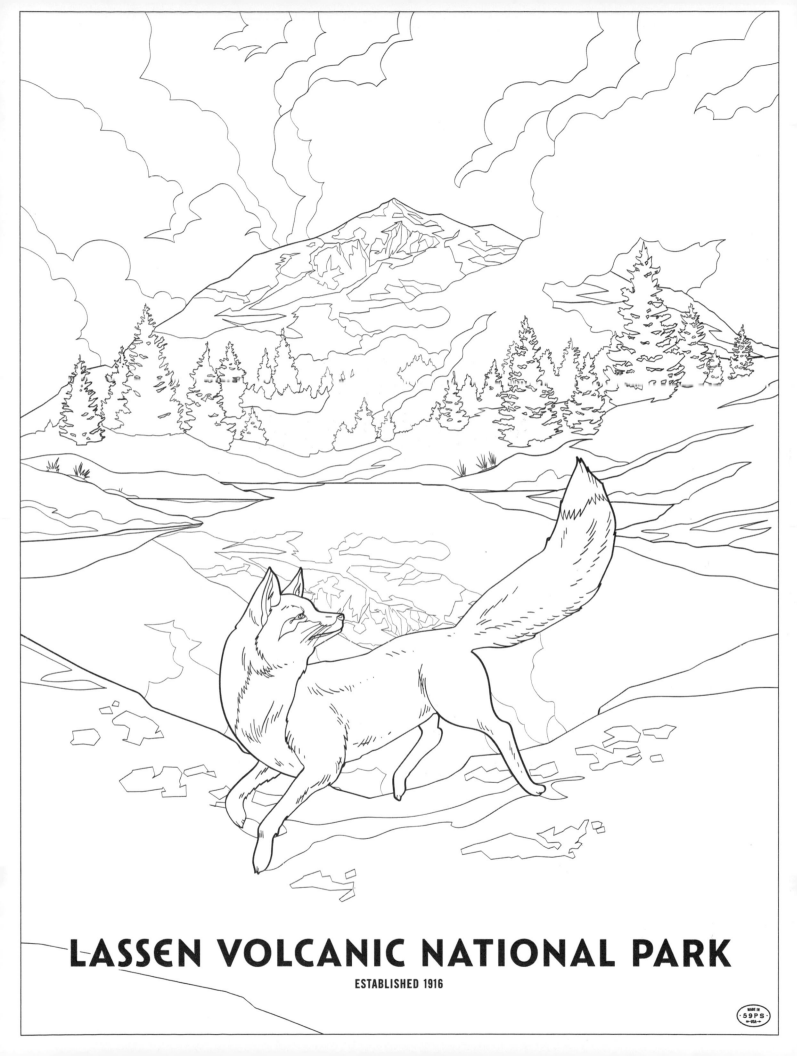

LASSEN VOLCANIC NATIONAL PARK

ESTABLISHED 1916

PINNACLES NATIONAL PARK

Offering exhilarating sights at every elevation, Pinnacles National Park is named for its high spires, which are the remains of an eroded volcano located on a fault line. These rock spires moved 200 miles from their original location as a result of the shifting fault. The pinnacles divide the park into its east and west sections and attract adventurous mountain climbers. Springtime brings the main attraction: the California condors and prairie falcons. The park also features intricate cave systems. There are entryways to these caves on each side of the park, at Bear Gulch Cave and Balconies Cave. At Hanging Rock, a huge boulder balances atop the tight canyon walls. Year round, streams trickle through these underground palaces.

THE WEST | STATE: CALIFORNIA | **ARTIST:** MIKE MCCAIN

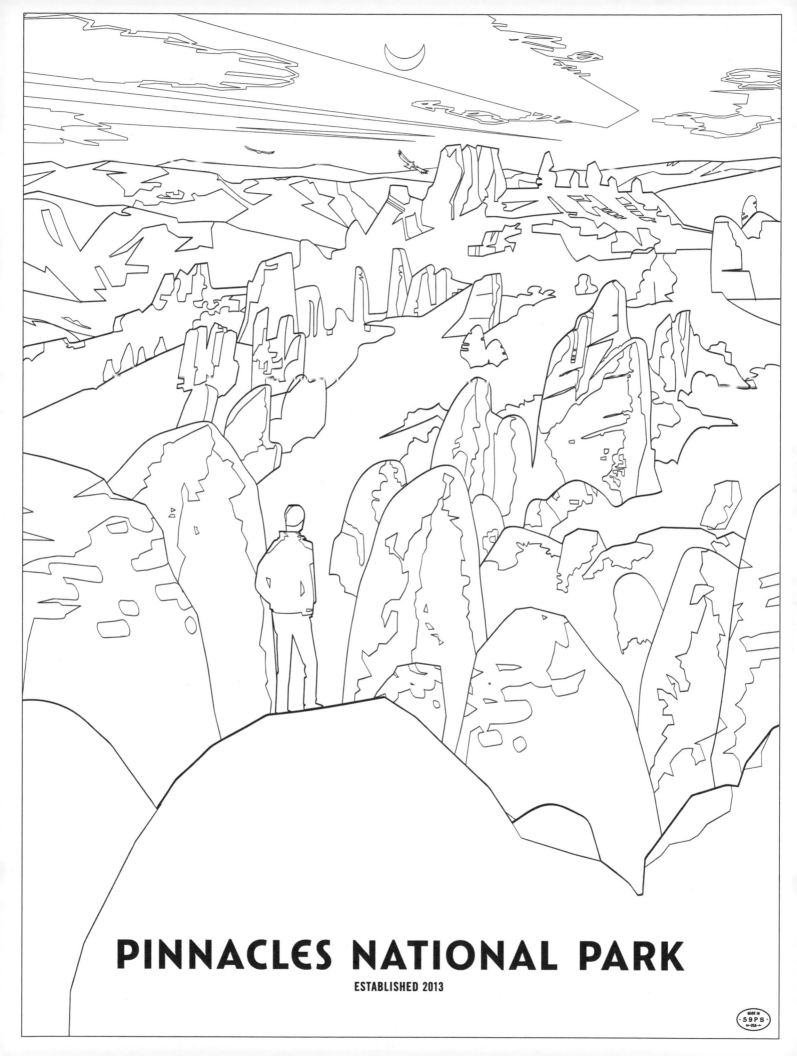

PINNACLES NATIONAL PARK

ESTABLISHED 2013

MADE IN
59 P S
USA

REDWOOD NATIONAL PARK

Nearly half of the redwoods in the world are grown at Redwood National Park, many of them more than 2,000 years old. The interconnected ecosystem maintains not only the world's largest trees, but also prairies, streams, rivers, and rich natural woodlands. Many of the animal species that call Redwood National and State Parks home, such as the northern spotted owl or the Steller's sea lion, have had their existence threatened over the years, but local conservationists and charities have come together to celebrate and protect this park and, in the end, the animals persevered.

THE WEST | STATE: CALIFORNIA | **ARTIST:** GLENN THOMAS

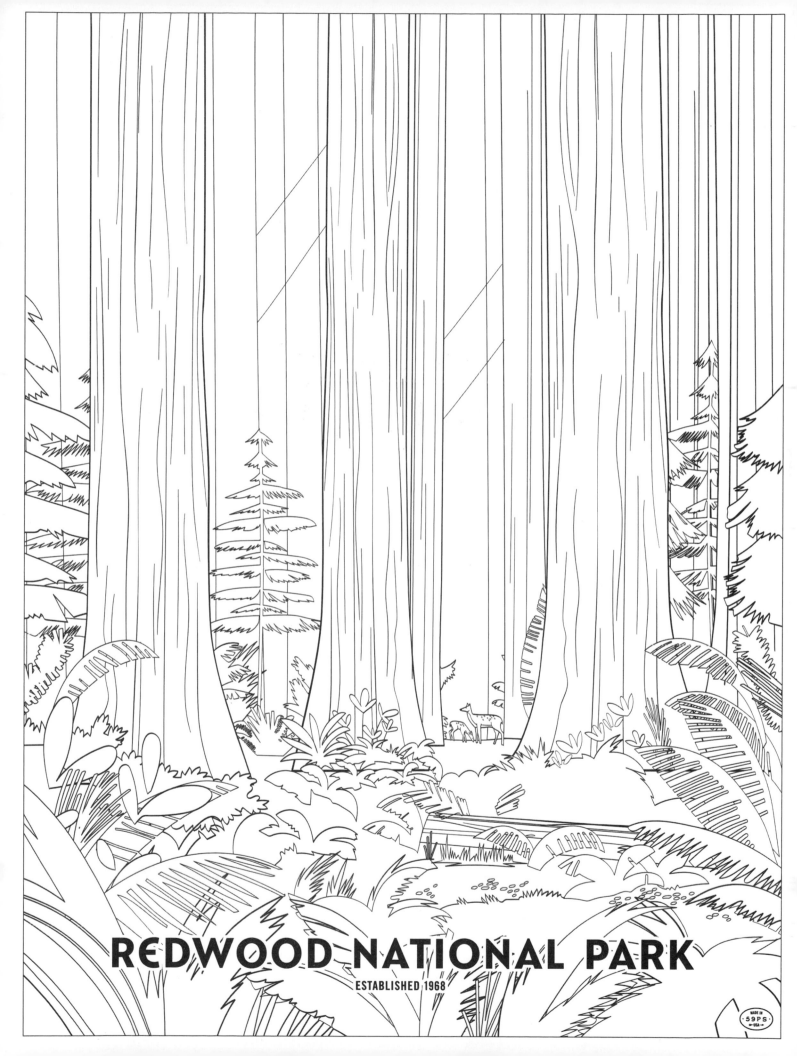

YOSEMITE NATIONAL PARK

Famed for its giant sequoia trees, Yosemite National Park has inspired generations of artists, writers, and politicians. Lakes gleam beneath sweeping mountain ranges speckled with blue-gray stone bluffs. Snowcapped mountains tower over fields of green. Deer graze alongside the sequoia groves while wolves tramp along the banks and black bears sleep in the tall grass. The famous landscape photographer Ansel Adams risked his life to capture the natural rock formation known as the Half Dome. Across the valley, another 3,000-foot-high vertical rock formation called El Capitan is ascended daily by rock climbers. Yosemite Falls is a marvel of nature, where three levels of rapids pour down between two sloping cliffs. Nearby, Horsetail Falls absorbs the sunset's orange hue, appearing as if it's on fire.

THE WEST | STATE: CALIFORNIA | **ARTIST:** DAN MCCARTHY

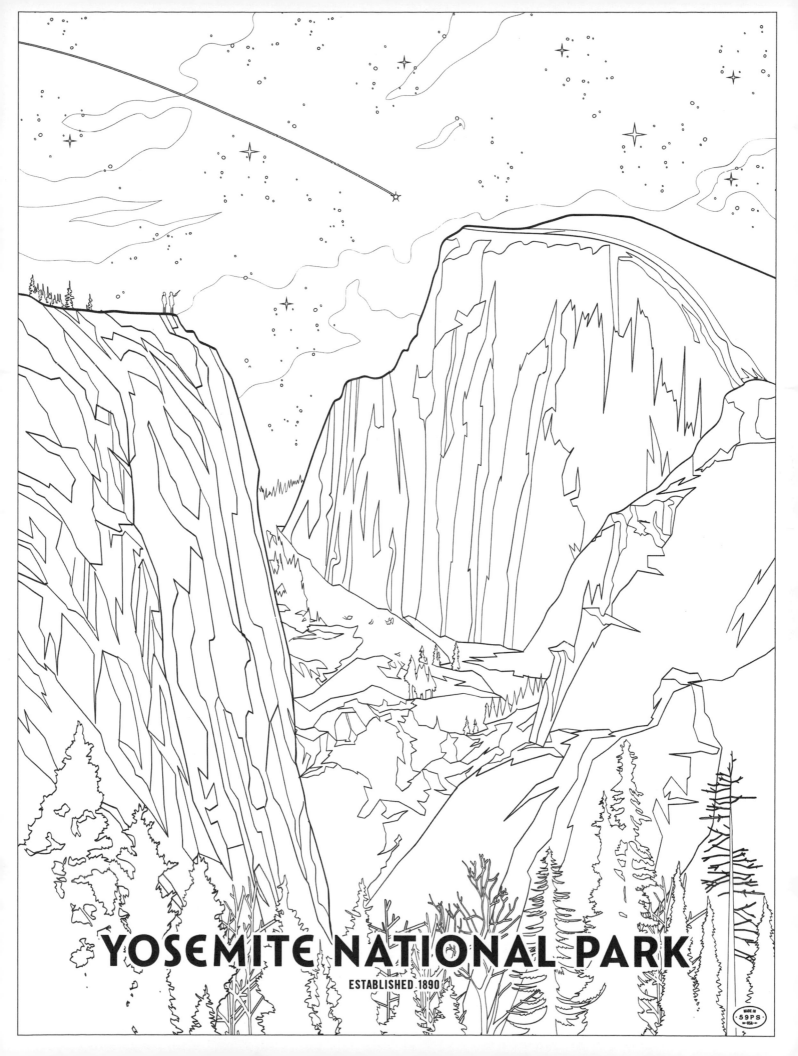

YOSEMITE NATIONAL PARK

ESTABLISHED 1890

SEQUOIA NATIONAL PARK

Groves of colossal sequoia trees and the tallest peak in North America can be found in Sequoia National Park. These trees are among the oldest living things on this earth. A fallen tree obstructing one of the roads was so massive that park personnel merely carved a tunnel into it so that visitors could drive through. There is as much to explore underground as on the surface: The park's extensive underground cave system includes more than eighty caves. Crystal Cave, the most famous, is a dark and enchanted castle decorated with stalactites and stalagmites of all sizes. The tallest tree, the oldest tree, and the highest peak—it's all here.

THE WEST | STATE: CALIFORNIA | **ARTIST:** GLENN THOMAS

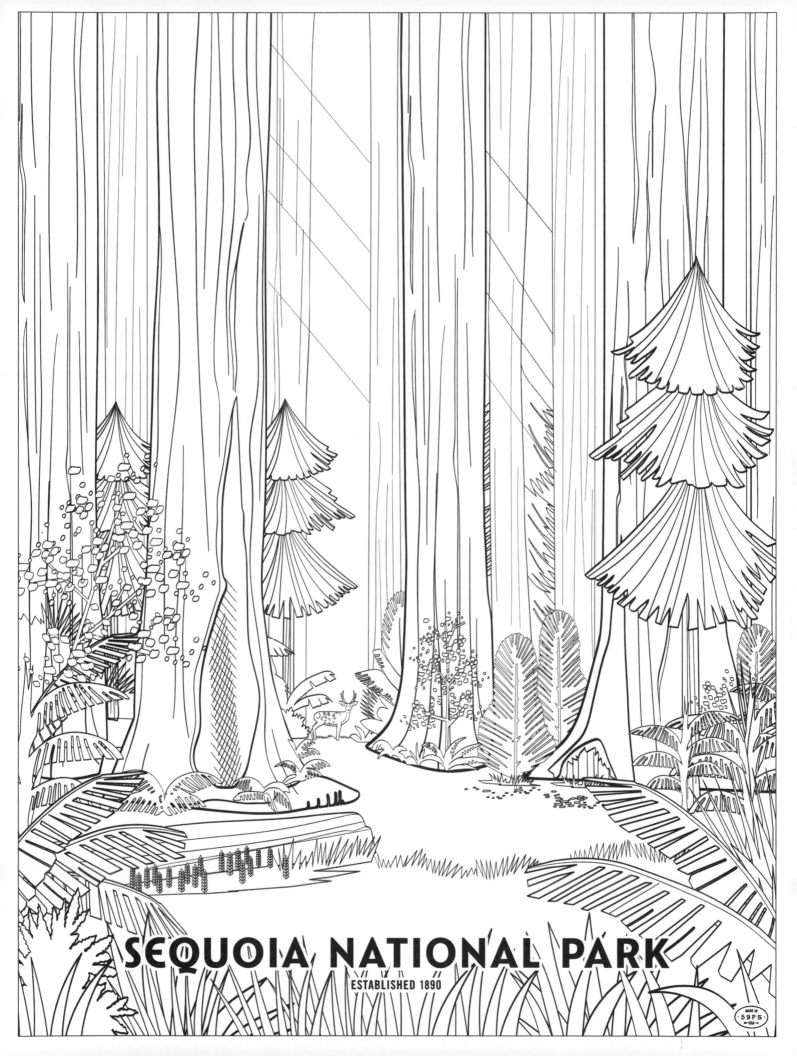

ARCHES NATIONAL PARK

With 2,000 naturally occurring arches, Arches National Park spans 120 square miles and reaches an elevation of 5,653 feet. It contains almost every size and shape of natural arch imaginable, from Landscape Arch, which looks like a treacherous drawbridge, to Double Arch, which resembles two arches growing out of one another. Arches National Park also boasts many other kinds of incredible desert phenomena. Dark Angel is a freestanding sandstone pillar that stretches 150 feet straight up in the air. The Fiery Furnace is a labyrinthian canyon with tight, mazelike walls. Balanced Rock, a 128-foot-high boulder that miraculously teeters 55 feet above an impossibly thin base, is visible as you drive to the park, inviting you to enter.

THE WEST | STATE: UTAH | **ARTIST:** NICOLAS DELORT

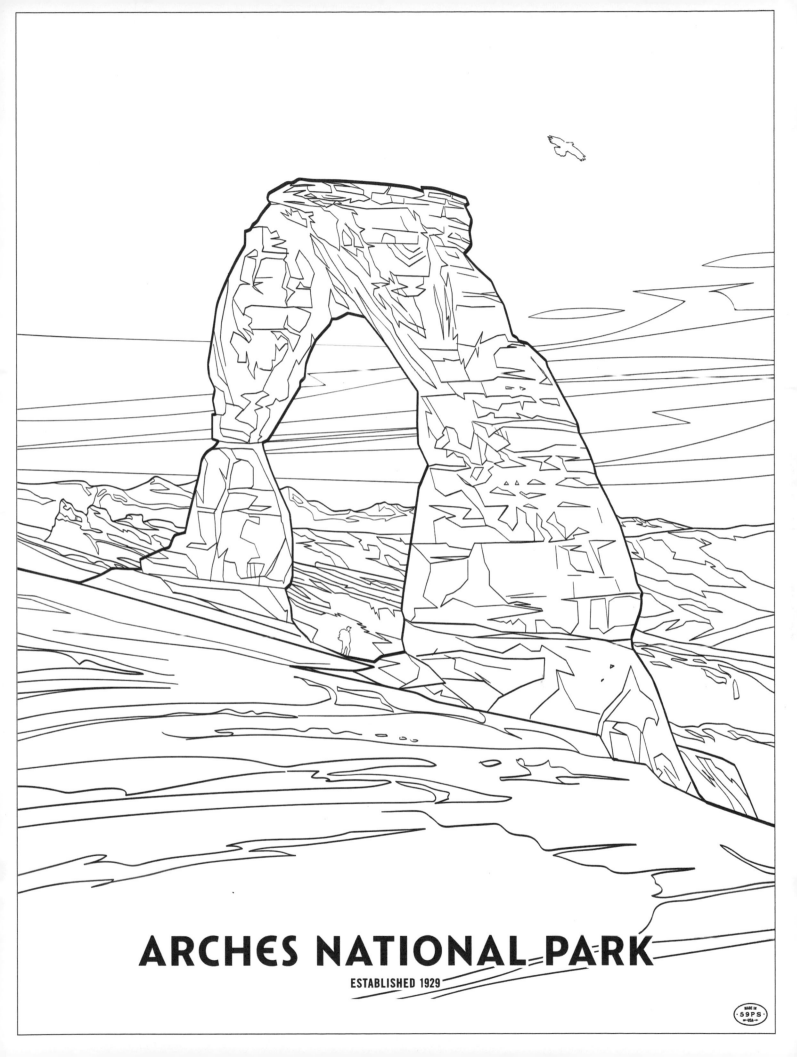

ARCHES NATIONAL PARK

ESTABLISHED 1929

CAPITOL REEF NATIONAL PARK

Greenery and streams can be found in Capitol Reef National Park alongside towering canyons, monoliths, and ridges. The park is named for the nautical term reef, meaning "barrier to passage," and for a natural dome which resembles the Capitol in Washington, DC. Fremont River and Pleasant Creek both run on the one-hundred-mile Waterpocket Fold. This defining feature of Capitol Reef is what's called a monocline: a wrinkle in the surface of the earth caused by a slight warping in the earth's crust. Occurring along a fault line, the movement of the fault caused an upward shift that in turn caused the rock to slope over itself, creating a staircase-like formation.

THE WEST | STATE: UTAH **| ARTIST:** CLAIRE HUMMEL

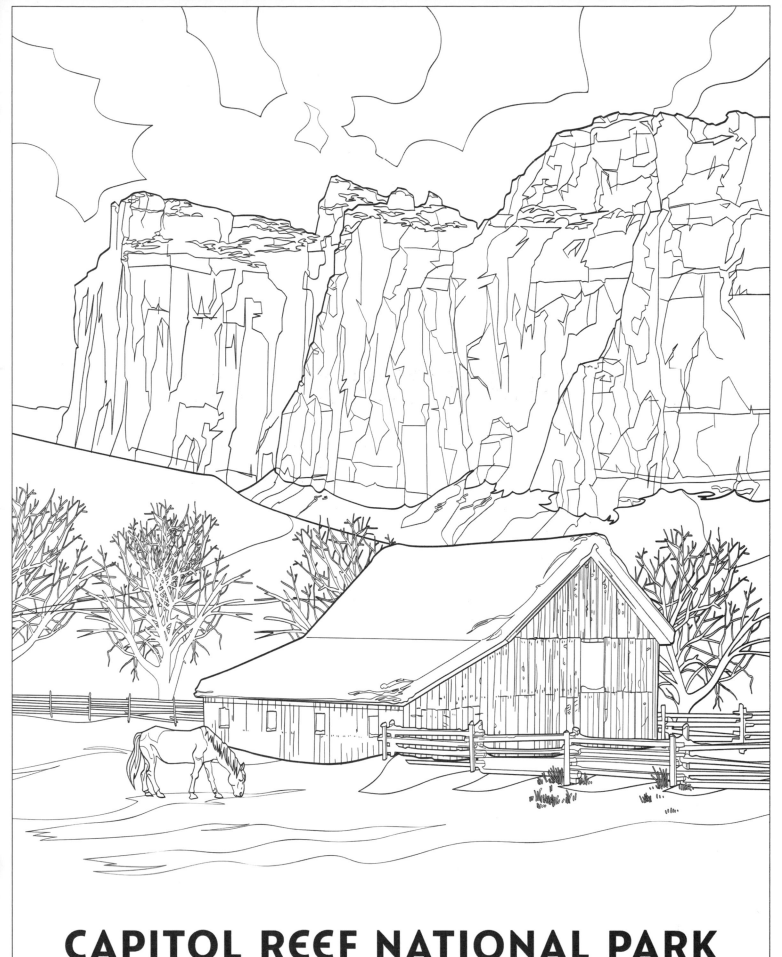

CAPITOL REEF NATIONAL PARK

ESTABLISHED 1971

ZION NATIONAL PARK

Formed by mesas, monoliths, buttes, arches, and canyons, Zion National Park contains 289 bird species and 79 species of mammals. Mormon settlers were so enamored by the area that they dubbed it Zion, a blessed land capable of bestowing divine tranquility upon believers. The main gorges in the park, Zion Canyon and Kolob Canyon, were formed by sedimentation and erosion over 150 million years. The water trickle from Weeping Rock's walls is hypnotizing, and the canyon's jutting overhang contains lavish hanging gardens where flowing water vacillates from a slow drip to a gush. Emerald Pools offers the opportunity to stand behind a 110-foot-high double waterfall. Water streams along the canyon floor as the echo of splashing footsteps bounces on the cave walls.

THE WEST | STATE: UTAH | **ARTIST:** DAN MCCARTHY

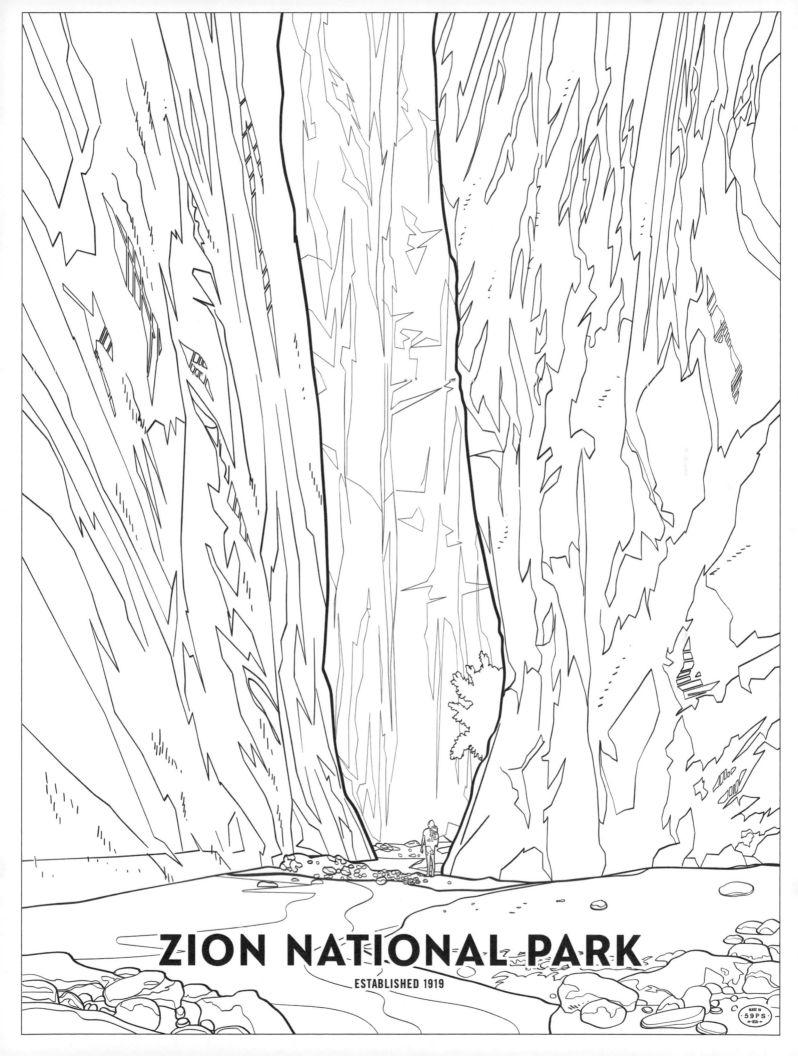

CANYONLANDS NATIONAL PARK

Four distinct districts—the Island in the Sky, the Needles, the Maze, and the Green & Colorado Rivers—separate Canyonlands National Park. The Colorado River, the Green River, and their tributaries eroded the canyons, mesas, and buttes that make up this gigantic 337,598-acre park. Island in the Sky sits on top of a 1,500-foot mesa, providing a panoramic view of the canyons. The Needles offers more of a backcountry experience, including day-long hikes replete with technicolor spires that gave the district its name. The Maze is harder to access but rewards visitors with the historic Horseshoe Canyon, home to pictographs and petroglyphs dating from as far back as 9000 BC. Canyonlands is a choose-your-own adventure that offers something to astound every explorer.

THE WEST | STATE: UTAH | **ARTIST:** DAN MCCARTHY

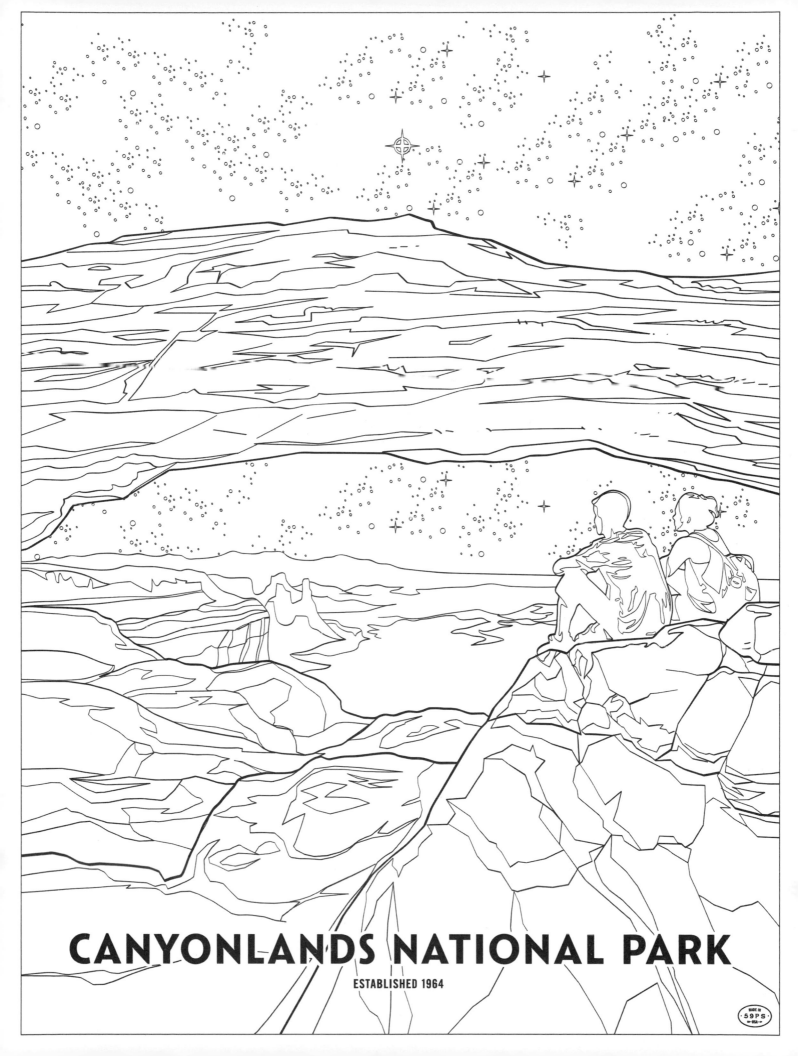

CANYONLANDS NATIONAL PARK

ESTABLISHED 1964

GREAT BASIN NATIONAL PARK

Located in eastern Nevada along the Utah border, Great Basin National Park encompasses 77,000 acres of desert bordered by soaring mountain ranges. The Basin and Range Province is a series of faulted mountains, valleys, and basins that stretches over most of the western United States and into Mexico. At 13,063 feet high, Wheeler Peak is the second-highest mountain peak in Nevada. At the base is one of the world's southernmost glaciers. Encased in rock and debris, the 120,000-square-foot glacier contains a wealth of minerals including marble, sandstone, and shale. Lehman Caves, a series of underground passageways formed hundreds of millions of years ago, also rests at the base of Wheeler Peak.

THE WEST | STATE: NEVADA | **ARTIST:** MARIE THORHAUGE

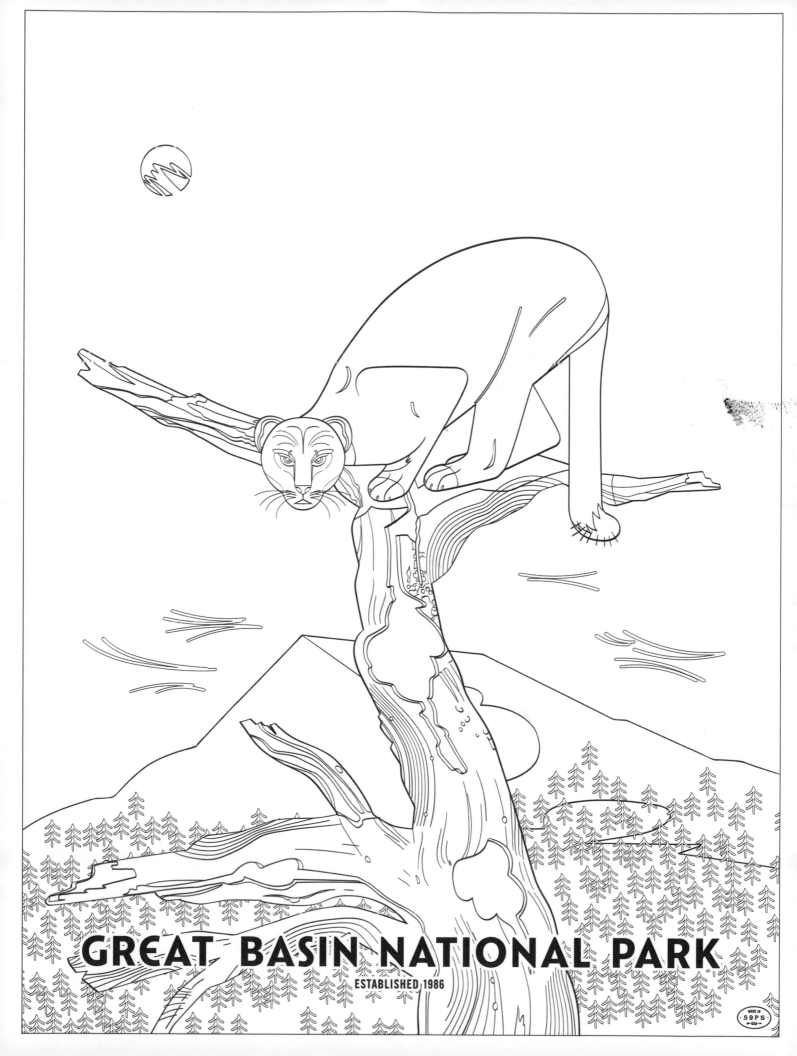

GREAT BASIN NATIONAL PARK

ESTABLISHED 1986

MOUNT RAINIER NATIONAL PARK

A colossal, snow-drizzled behemoth of a mountain, Mount Rainier National Park's idyllic beauty is almost enough to make visitors forget that the active stratovolcano is one of the world's most dangerous volcanoes. Much of the surrounding area is lush, with babbling brooks around every turn. In the section of the park called Paradise, billowing hills host efflorescent violet and red wildflowers. The Ohanapecosh River runs alongside the Grove of the Patriarchs, where towering trees can be seen from a suspension bridge above the water. Mowich Lake sits inside the basin of Carbon Glacier, one of many glaciers stacked upon the giant mountain at the park's center. Reflection lakes like the one at Sunrise Point provide a perfect mirror of Mount Rainier in all its majesty.

THE NORTHWEST | STATE: WASHINGTON **| ARTIST:** GLENN THOMAS

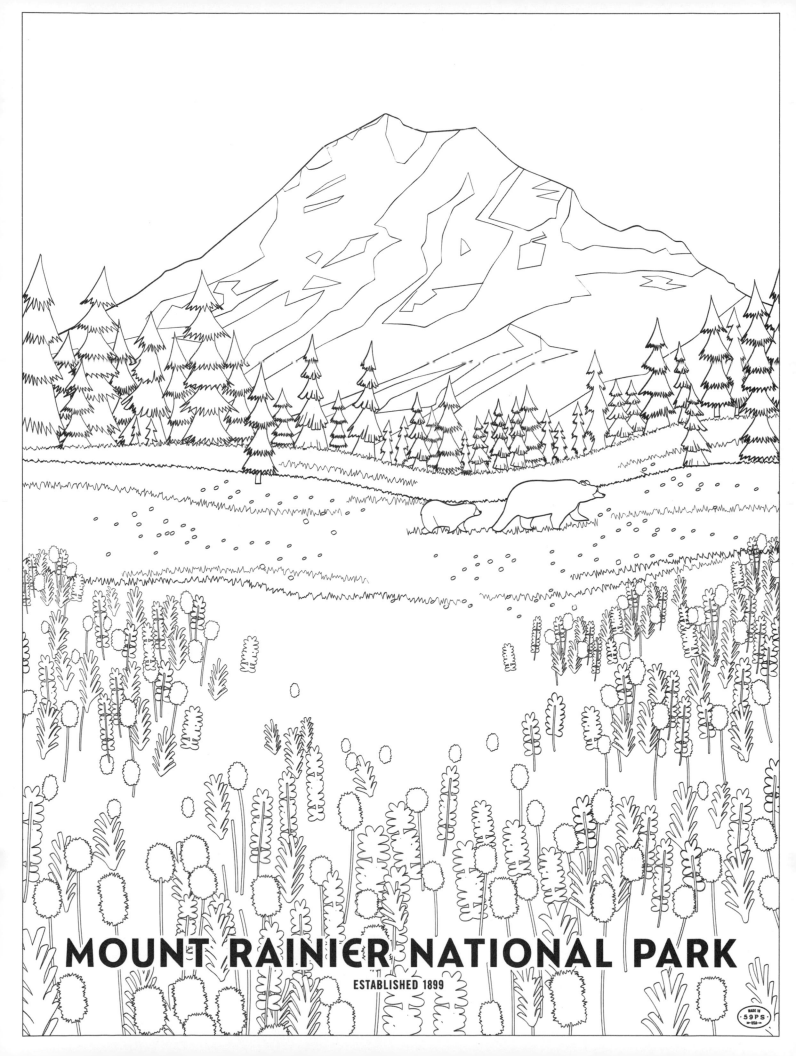

MOUNT RAINIER NATIONAL PARK

ESTABLISHED 1899

NORTH CASCADES NATIONAL PARK

Mountains and glaciers surround the over 500,000 acres of North Cascades National Parks, with peaks just cresting over 9,000 feet. It is a diverse region, with snowy mountains on one end and waterfalls and gushing whitewater on the other. There are few man-made structures or roads. More than half the glaciers in the contiguous United States can be found here. It's no wonder that author Jack Kerouac escaped to this wilderness on his quest for a Zen state of mind. The sound of chirping birds and babbling rivers and streams creates a feeling of deep tranquility, even if the surrounding mountains have names like Mount Terror, Poltergeist Pinnacle, and Ghost Peak.

THE NORTHWEST | STATE: WASHINGTON | **ARTIST:** BENJAMIN FLOUW

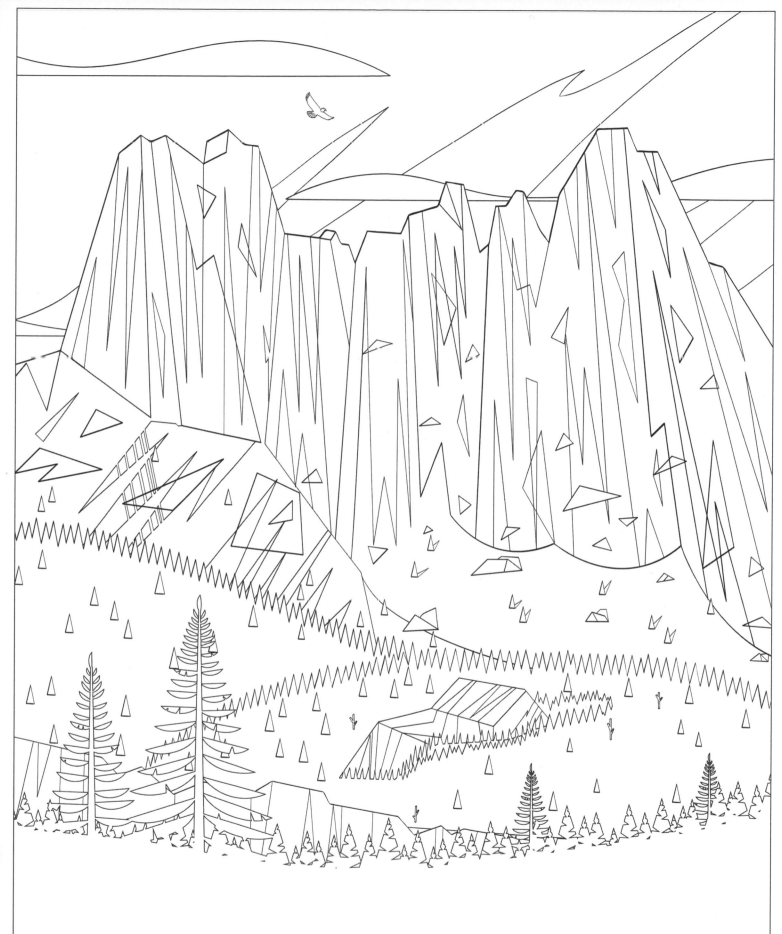

NORTH CASCADES NATIONAL PARK

ESTABLISHED 1968

OLYMPIC NATIONAL PARK

Encompassing nearly a million acres, Olympic National Park is so big that it is often experienced as three separate locales. The coastal area, Ruby Beach, is a stretch of shoreline flanked by sea stacks. The glaciated mountains at the park's center include the Olympic Mountains. Due to frequent snow, these mountains are the most glaciated nonvolcanic mountains in the contiguous United States. The western side of the park houses a temperate rainforest. Receiving up to twelve feet of rain annually, the area is the wettest in the contiguous United States. The wetness and cold temperatures make Olympic's rainforest uniquely coniferous, with spruce, hemlock, and cedar trees rising up to 300 feet tall.

THE NORTHWEST | STATE: WASHINGTON **| ARTIST:** DANIEL DANGER

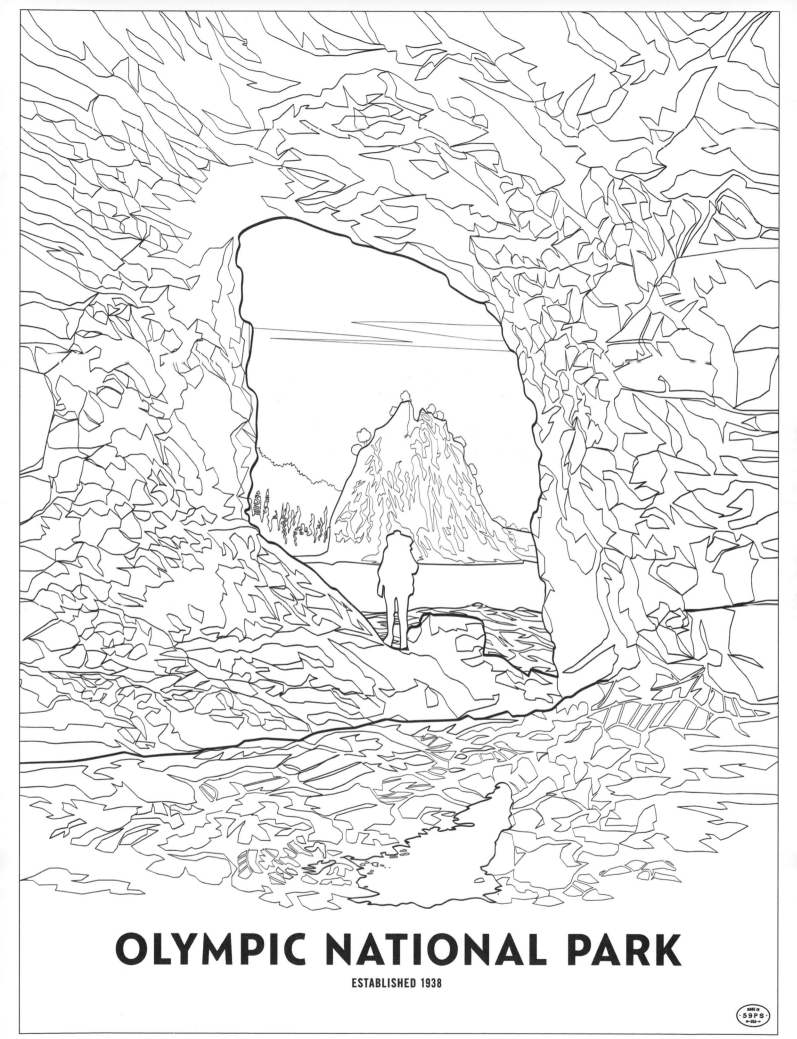

OLYMPIC NATIONAL PARK

ESTABLISHED 1938

CRATER LAKE NATIONAL PARK

A caldera formed by the eruption of the now-defunct volcano Mount Mazama, Crater Lake National Park contains the United States' deepest lake. Swimming is permitted and you can even enter the water by jumping from the thirty-five-foot cliff at the end of Cleetwood Cove Trail. The unusual blue color is due to the lake's water coming entirely from rain and snow. As a result, Crater Lake is one of the world's clearest and cleanest lakes. The park also offers forty caves and ten waterfalls to explore. Hikes through the 50,000 acres of old-growth forest offer remarkable views of the lake and mountains, revealing the stark beauty of Crater Lake National Park.

THE NORTHWEST | STATE: OREGON **| ARTIST:** DAN MCCARTHY

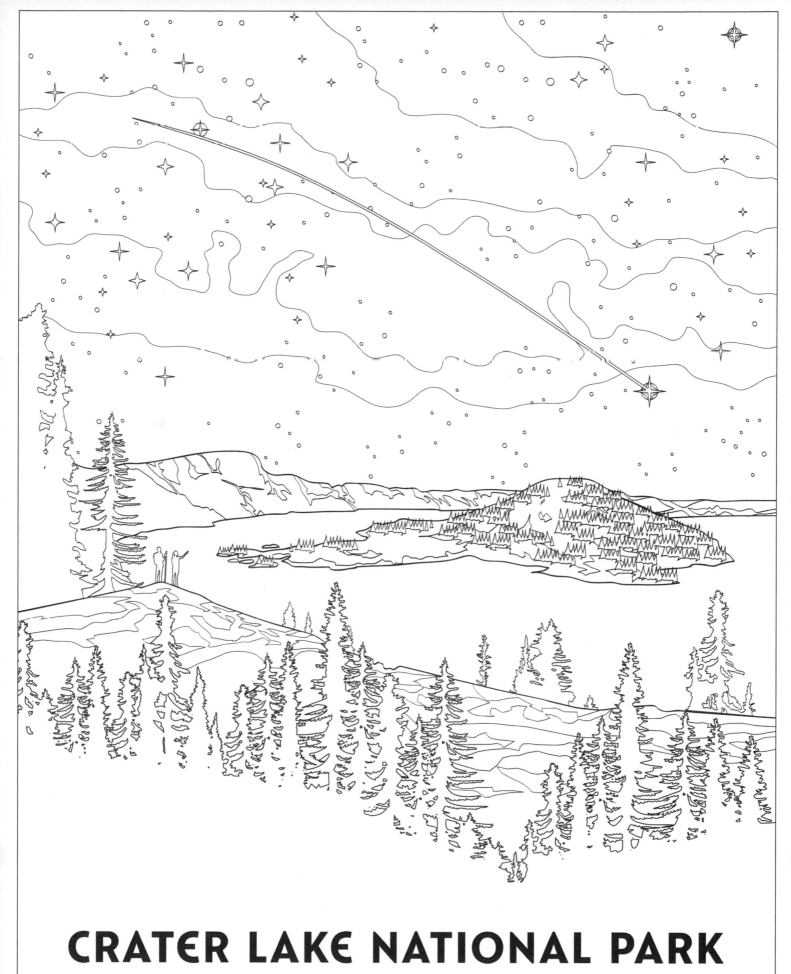

CRATER LAKE NATIONAL PARK

ESTABLISHED 1902

DENALI NATIONAL PARK

With treacherous mountains, slippery glaciers, and 350 grizzlies, Denali National Park is not easily traversed. Trails are few and far between. Rivers and lakes aren't bridged over. There's only one way into this ice kingdom: a ninety-one-mile-long road, most of which is braved exclusively by Park Service shuttles. Once inside, mossy boreal forests greet you with black spruce, white spruce, birch, and aspen trees. During autumn, thousands of caribou graze in the open tundra. At the sled dog kennels, you'll meet the brave mushers who help the park rangers police the premises. Long winter nights in Denali offer stunning views of the aurora borealis, one of the many rewards for striking out into the great unknown.

THE NORTHWEST | STATE: ALASKA **| ARTIST:** DAN MCCARTHY

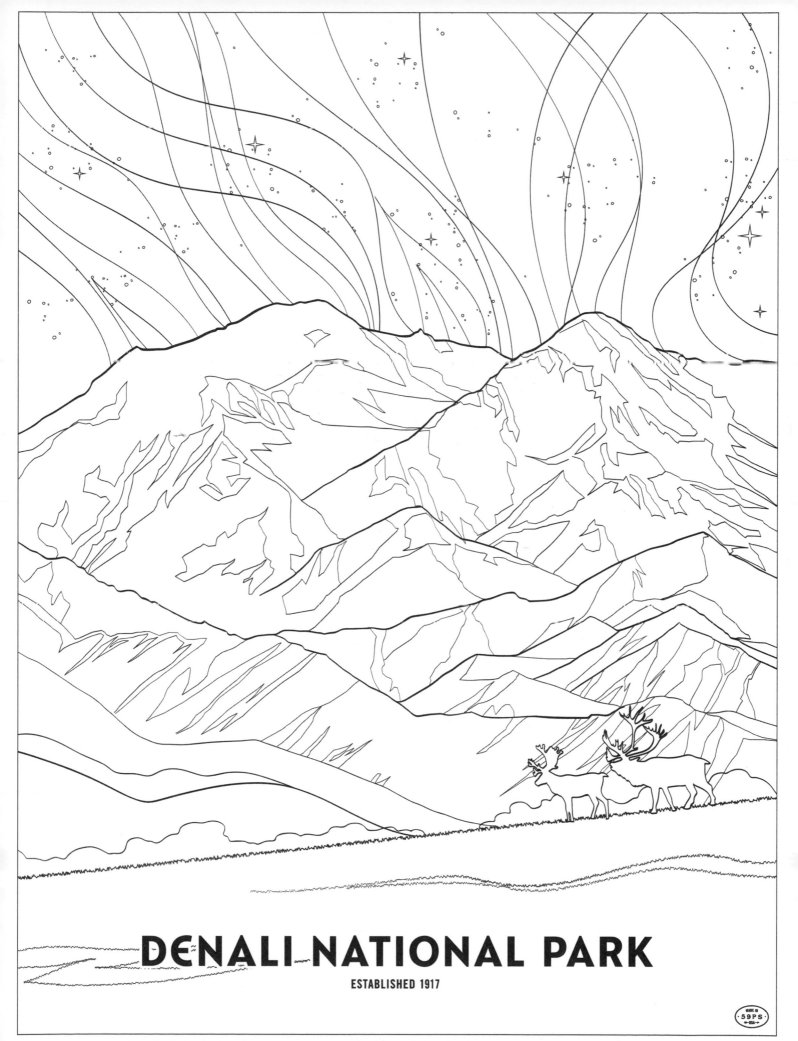

DENALI NATIONAL PARK

ESTABLISHED 1917

GATES OF THE ARCTIC NATIONAL PARK

The most remote park in the country, Gates of the Arctic National Park is stationed far above the Arctic Circle and includes 8.4 million acres of snow-blasted mountains, undulating sand dunes, and lively forests. Here, grizzly bears storing up for the winter pluck dog salmon from the dashing streams. During the unforgiving bleakness of winter, Dall sheep patrol the mountain ridges. Gray wolves trek through the snow, hunting and howling in packs. Pristine white polar bears wrestle each other between feasts. The once nearly extinct musk ox now thrives in the park; sporting the longest fur of any living mammal, the musk ox's ultra-warm mane provides the perfect padding for the bitter cold.

THE NORTHWEST | STATE: ALASKA **| ARTIST:** LEESHA HANNIGAN

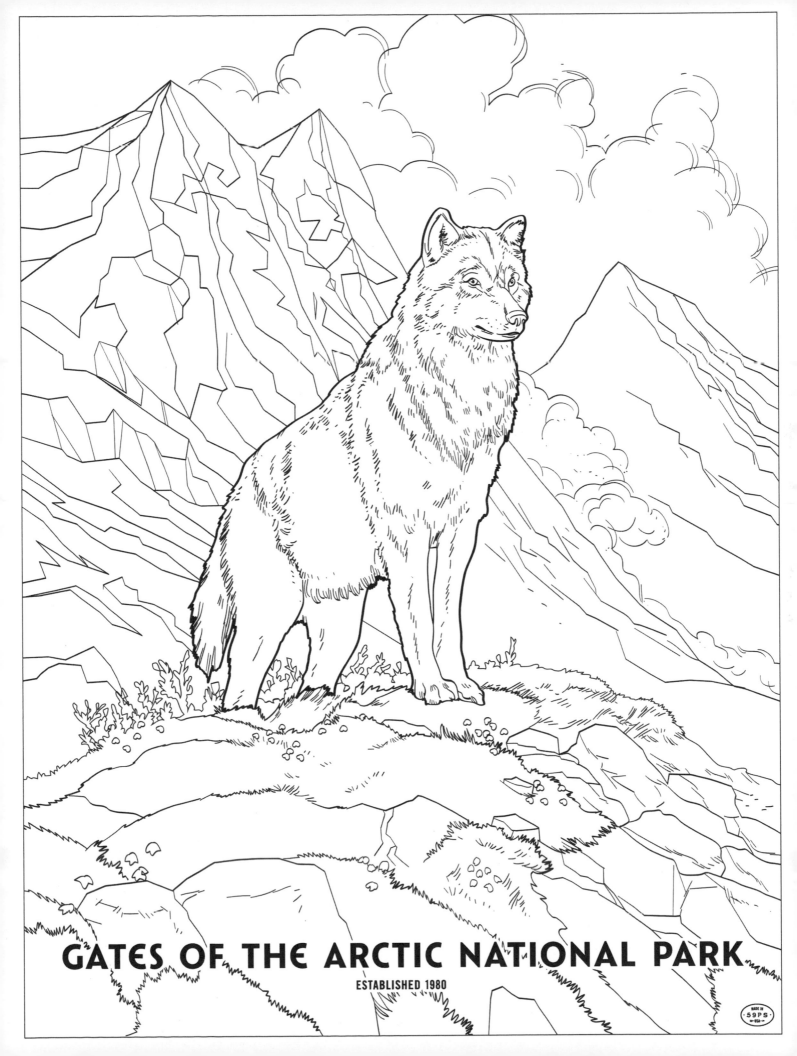

GATES OF THE ARCTIC NATIONAL PARK

ESTABLISHED 1980

GLACIER BAY NATIONAL PARK

In the islands of the Alexander Archipelago, bears, lynx, and wolverines call Glacier Bay National Park's inlets and islands home, with whales claiming the bay. This park is a massive display of raw and unfettered wilderness still engulfed by the ice that once covered the globe. The slow retreat of a 4,000-foot-thick glacier left behind a nearly seventy-mile-long cerulean bay with palatial glaciers still looming. Over time, new forests were born, and a profusion of spruce and hemlock trees painted the land in hues of dark green. Humpback and killer whales ascend from the bay's depths, twisting above the surface for air before diving back into the Arctic sea.

THE NORTHWEST | STATE: ALASKA **| ARTIST:** OLIVER BARRETT

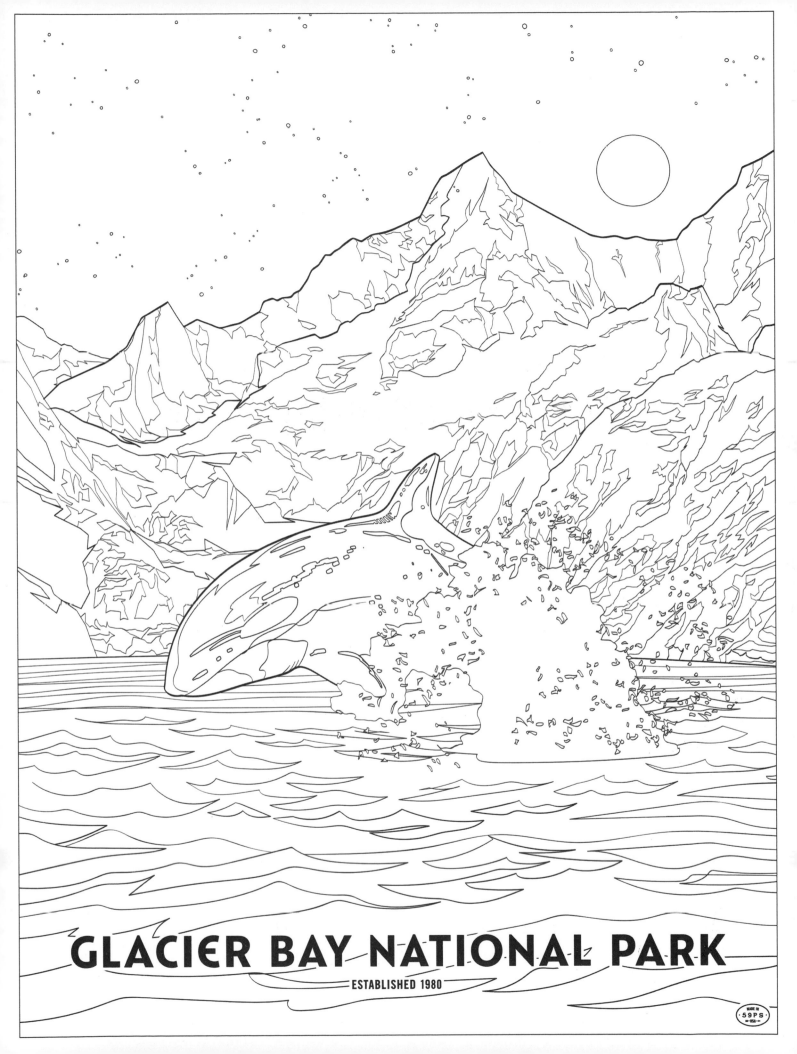

GLACIER BAY NATIONAL PARK

ESTABLISHED 1980

KATMAI NATIONAL PARK

Infamous for the largest volcanic eruption of the twentieth century, life continues to reclaim Katmai National Park. The 1912 Novarupta eruption released thirty times the magma of Mount St. Helens. Ash, pumice, and rock blanketed the surrounding valley and was flung as far away as Texas. In the aftermath of Novarupta's explosion, the area was so gaseous that scientists and their dogs had to wear gas masks to survey it. Today, the park is safe to explore, and fjords and bays surround the valleys. The biggest attraction comes in mid-July, when people gather at Brooks Falls to watch brown bears snatch sockeyes out of the river with their teeth. With over 2,000 brown bears in the park, Katmai has become the nation's premier bear-watching locale.

THE NORTHWEST | STATE: ALASKA | **ARTIST:** LEESHA HANNIGAN

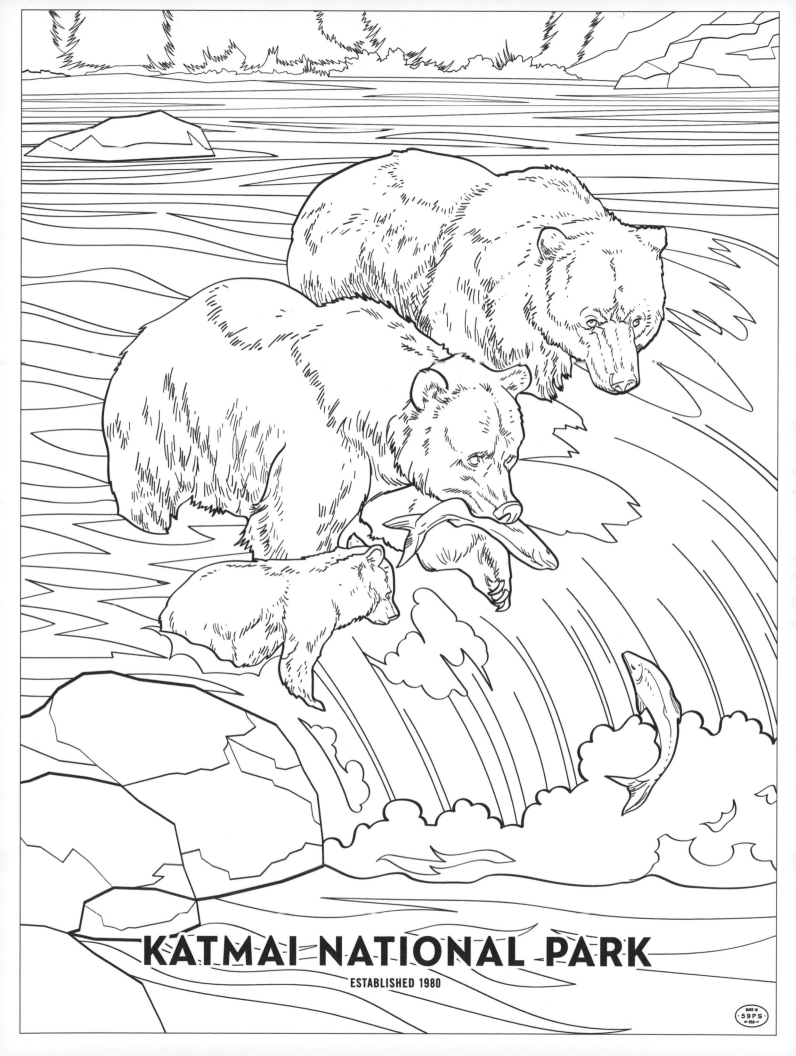

KATMAI NATIONAL PARK

ESTABLISHED 1980

KENAI FJORDS NATIONAL PARK

With forty glaciers carving out the coastline, Kenai Fjords National Park is a blinding white expanse of ice and ocean. Melting snow on the cliffs creates a constant sheen of crystal-clear water and a haze of smoke that floats like a halo around the park. Meanwhile, the wilderness is lush and green, with conifers adorning the slopes. At the Harding Icefield, 700 miles of thick ice form a crust of jagged spikes along the surface. The ice floes make the fjords a haven for seals. Sea lions gather and lounge on the small islands of the area. A visit to Kenai Fjords National Park is an integral experience for anyone wanting to comprehend the delicate interplay between our mountains, glaciers, and the ocean.

THE NORTHWEST | STATE: ALASKA | **ARTIST:** MATTHEW WOODSON

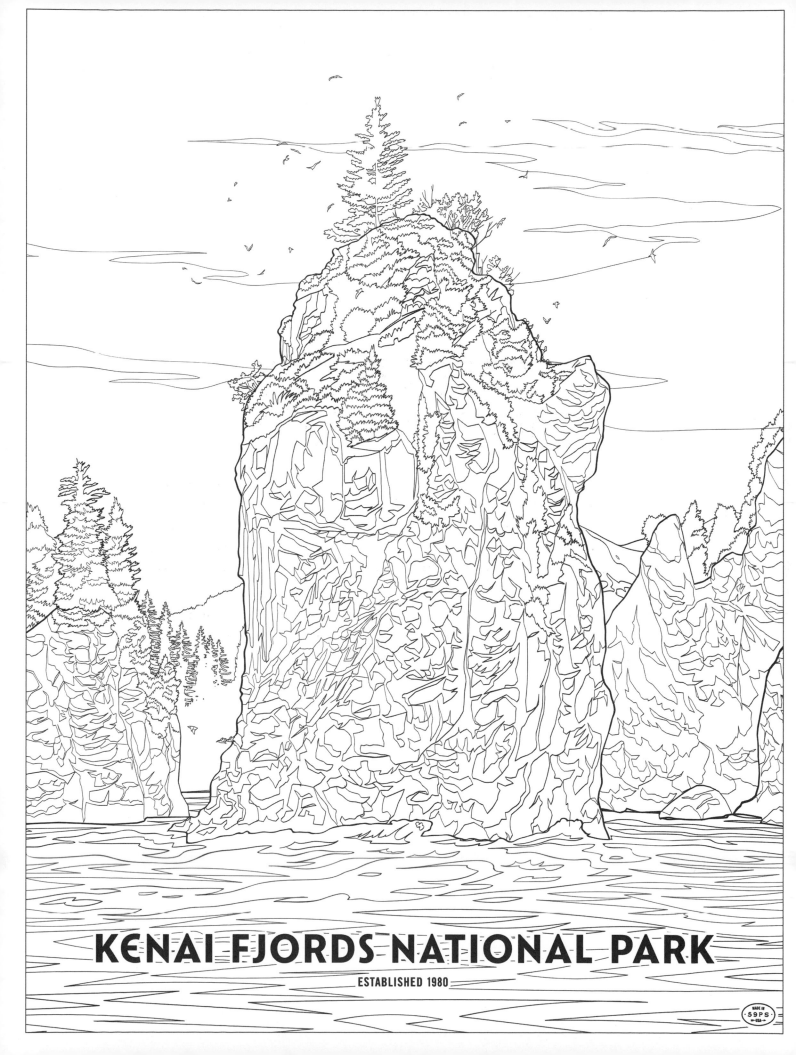

KENAI FJORDS NATIONAL PARK

ESTABLISHED 1980

KOBUK VALLEY NATIONAL PARK

One of the country's most remote wilderness preserves, Kobuk Valley National Park is spread across over two million acres of wilderness. Kobuk Valley is like a reverse oasis—a landscape of hazy sand dunes in the middle of the Arctic tundra. The dunes are the result of 30,000-year-old glaciers grinding the rocks beneath them into sand that then blew up onto the Kobuk River's southern bank. Every year, when herds migrate across the river, the native Inuit population seizes their one opportunity to hunt their yearly allotment of caribou. The Inuit are careful not to kill any more than they need to feed their families as the caribou's annual return has been integral to their survival for centuries.

THE NORTHWEST | STATE: ALASKA **| ARTIST:** DAVID DORAN

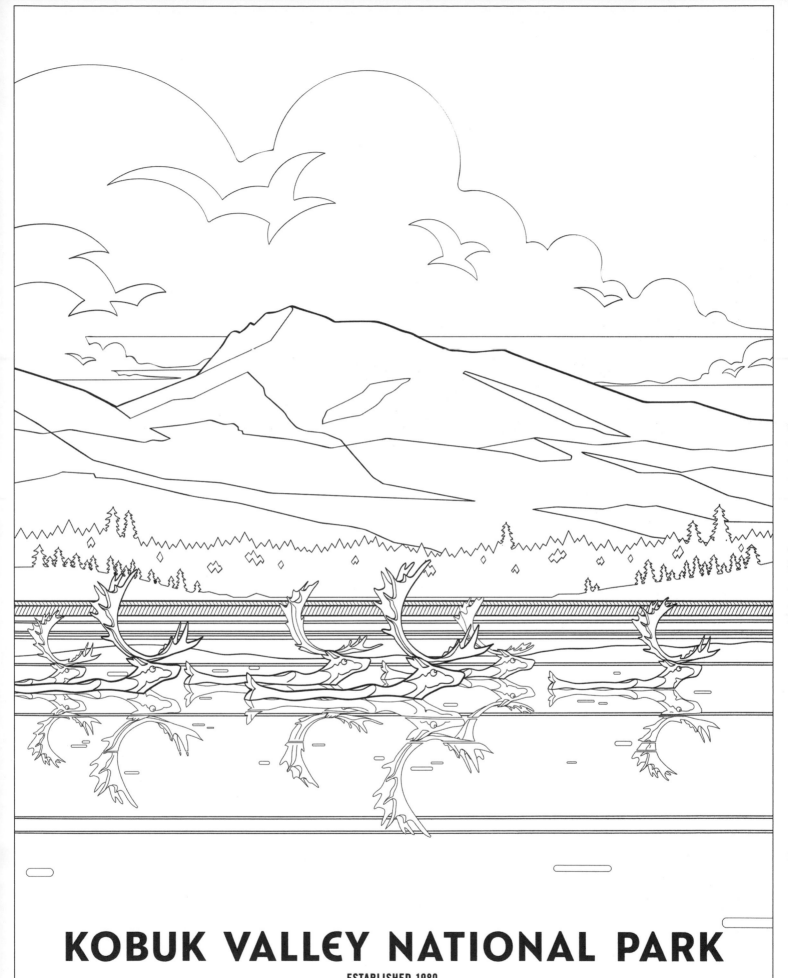

KOBUK VALLEY NATIONAL PARK

ESTABLISHED 1980

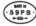

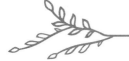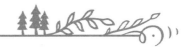

LAKE CLARK NATIONAL PARK

Accessible only by boat or float plane, Lake Clark National Park got its name from a forty-mile-long and five-mile-wide pool of fresh teal water, surrounded by mountains, volcanoes, glaciers, prairies, bogs, and shoreline. Alaskan brown bears gather in the park's meadows and fish for salmon in the bright blue lake, as the park is located at the headwaters of the Bristol Bay sockeye salmon run. Dall sheep climb the impossibly steep mountains. Caribou migrate through the tundra. Otters frolic in the lakes and rivers. Foxes peer out from the cliffs around the lake. The Chigmit Mountains split the park in two. The plethora of wildlife native to Alaska all converge here, making Lake Clark the definitive Alaska experience.

THE NORTHWEST | STATE: ALASKA | **ARTIST:** KRISTEN BOYDSTUN

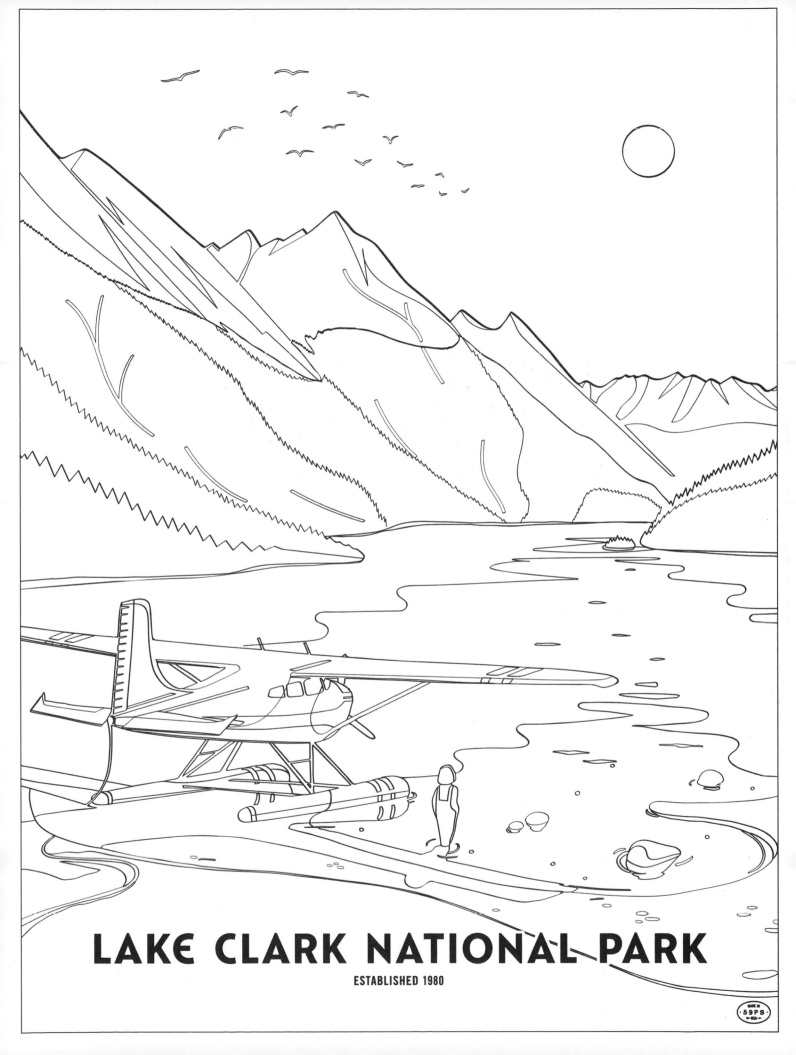

LAKE CLARK NATIONAL PARK

ESTABLISHED 1980

WRANGELL—ST. ELIAS NATIONAL PARK

The largest national park in the US, Wrangell—St. Elias National Park offers the most glaciers, the most Dall sheep, the largest grizzly bears, and the highest peaks of any park or preserve in the country. Because only two roads run through the park, much of its land is accessible only by plane. In 1898, settlers discovered huge deposits of copper in the Kennecott Mountains. Kennecott quickly became a mining boom town; but then, just as swiftly, the mining company dissolved, leaving a ghost town behind. Today, people visit the abandoned Kennecott homes and restored mine that was once among the most successful in the country. The town and mine are reminders that natural beauty is a gift worth infinitely more than mineral rights.

THE NORTHWEST | STATE: ALASKA | **ARTIST:** DANIEL DANGER

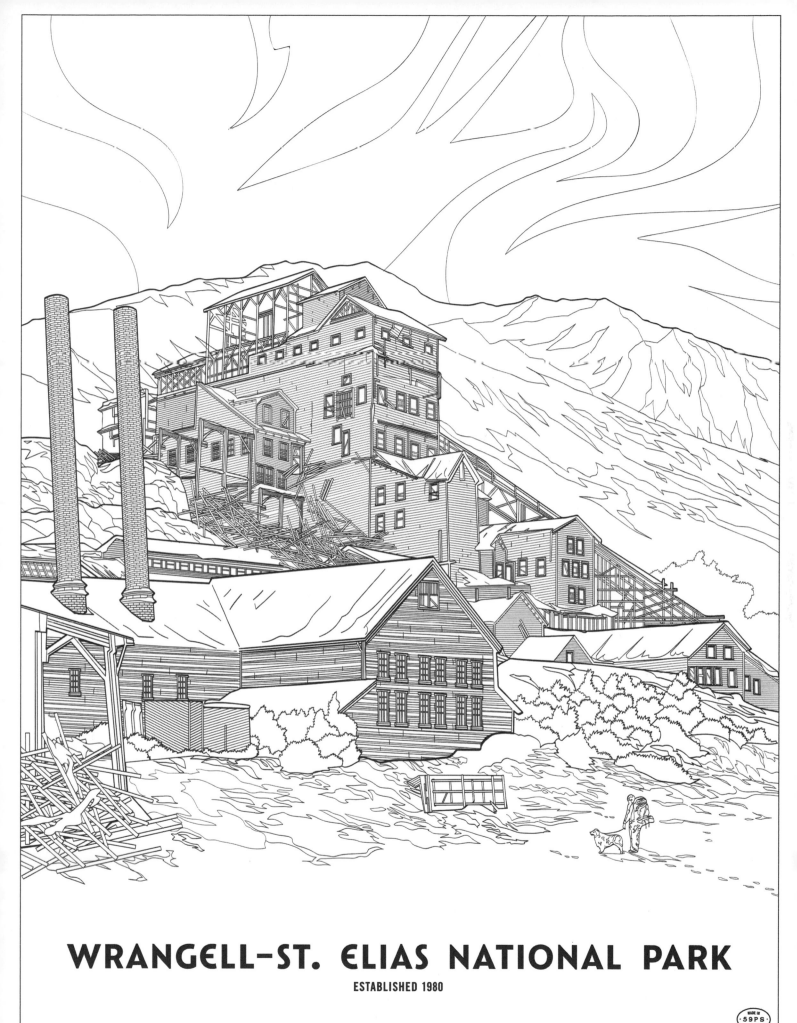

WRANGELL–ST. ELIAS NATIONAL PARK

ESTABLISHED 1980

CHANNEL ISLANDS NATIONAL PARK

Five islands—Anacapa, Santa Barbara, Santa Cruz, San Miguel, and Santa Rosa—make up Channel Islands National Park. The largest, Santa Cruz, is nearly the size of a small American city, and the smallest, Santa Barbara, is barely a single square mile. Half of the 249,354 acres that make up the park are underwater. Bottlenose dolphins play in the waves, sea otters float near the shore, and sea lions lounge on the beach. The Anacapa Island Lighthouse was once a beacon for ships braving the Pacific. All five islands are biosphere reserves, meaning that wildlife is fastidiously protected. This park is a testament to the value of preservation.

THE PACIFIC | STATE: CALIFORNIA **| ARTIST:** SOPHIE DIAO

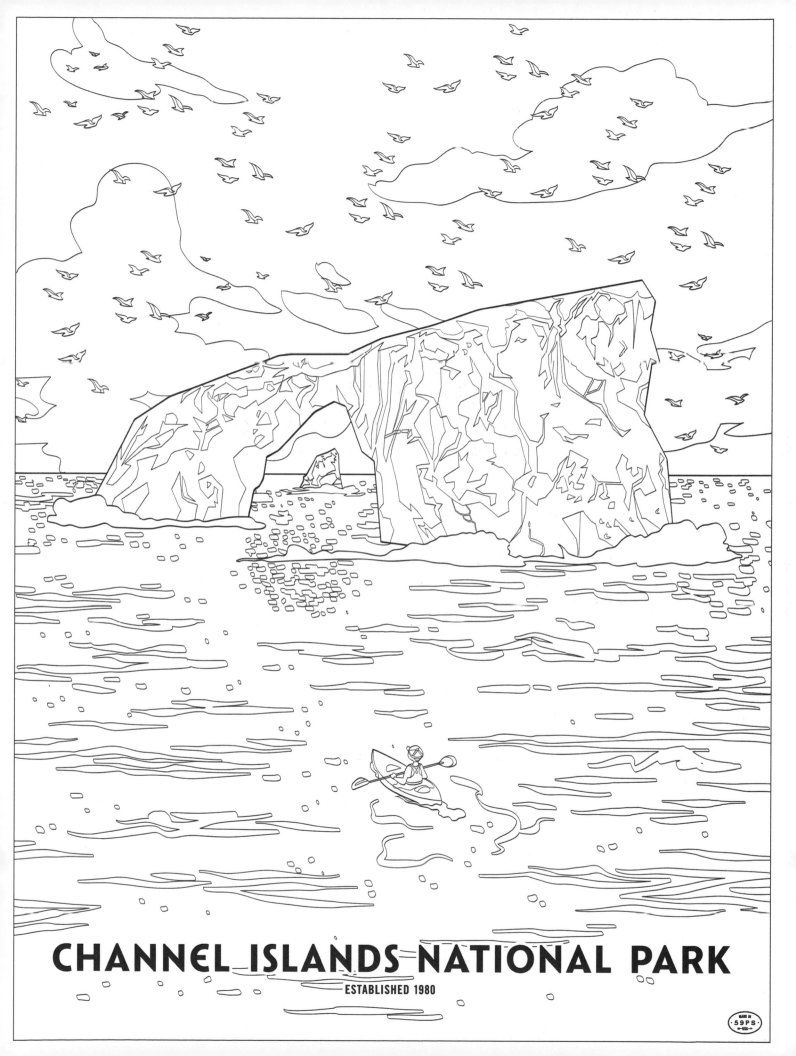

CHANNEL ISLANDS NATIONAL PARK

ESTABLISHED 1980

HALEAKALĀ NATIONAL PARK

Dotted with craters, cinder cones, and volcanic phenomenon, Haleakalā National Park consists of five square miles of land surrounding a defunct volcano. Puʻuʻulaʻula, the highest point on the island, stands 10,020 feet tall and looks down upon the Haleakalā Crater Valley. The crater plunges down 2,600 feet deep. The scenic Hāna Highway leads to the Kīpahulu Valley. The upper valley is an inaccessible but integral rainforest preserve that protects plants and animals from around the world, including some that exist nowhere else on the globe. Below this preserve is a collection of freshwater pools, cascading streams, and waterfalls. The Seven Sacred Pools of ʻOheʻo, a series of waterfalls carved out over centuries by rainforest streams, embodies the essence of island paradise.

THE PACIFIC | STATE: HAWAII **| ARTIST:** DAN MUMFORD

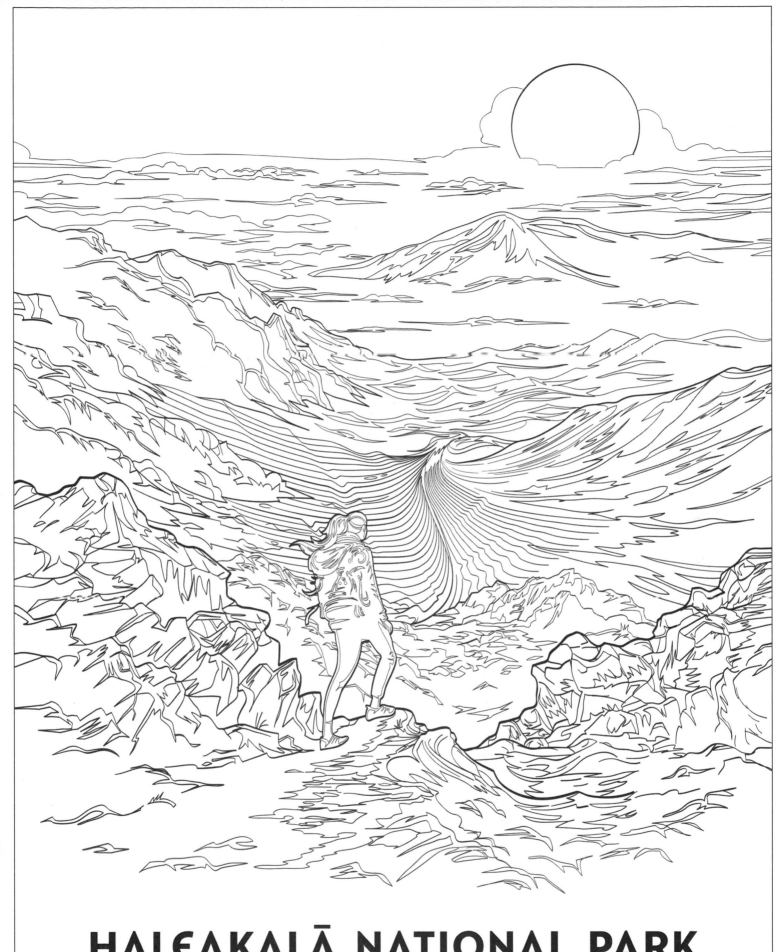

HALEAKALĀ NATIONAL PARK

ESTABLISHED 1961

HAWAII VOLCANOES NATIONAL PARK

You can literally watch Hawaii Volcanoes National Park transform before your very eyes. The park contains two volcanoes: the world's largest shield volcano, the 13,679-feet-tall Mauna Loa, and the world's most active volcano, the 4,091-feet-tall Mount Kilauea. Between 1983 and 2018, Kīlauea erupted continuously. In May 2018, a massive explosion of lava from Kīlauea caused untold damage to nearby communities and ecosystems. Today, visitors can still drive right up to the summit of this lake of fire. Lava from Kīlauea is carried to the Pacific Ocean through underground "lava tubes." When portions of the roof of these tubes fall off they create "skylights" that allow us to witness the fiery stream inside. Hawaii Volcanoes National Park teaches visitors exactly how land forms anew.

THE PACIFIC | STATE: HAWAII | **ARTIST:** VINCENT ROCHE

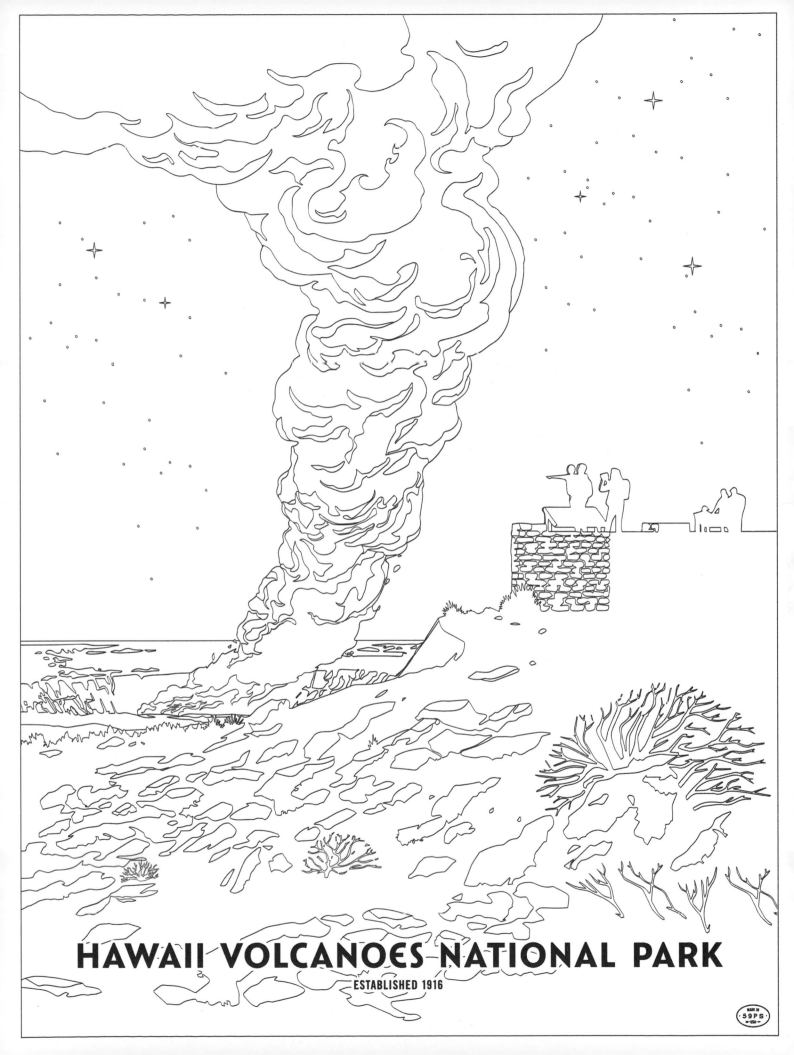

HAWAII VOLCANOES NATIONAL PARK

ESTABLISHED 1916

NATIONAL PARK OF AMERICAN SAMOA

Tropical biodiversity ranging from mountains and volcanoes to coral reefs and rainforests can be found in the National Park of American Samoa. Situated along three Oceanic islands, tide pools and sparkling waterfalls accent the beauty of this paradise. The culture of the Samoan people is close-knit and many locals host park visitors in their own homes. Efforts to establish the park began in 1984 as an attempt to protect the island's rainforest and endangered wildlife. Because Samoans don't believe in land ownership, it took several years of deliberation. In 1988, island councils agreed to lease the land to the National Park Service for fifty years provided the agency agreed to protect the sanctity of the region's natural gifts.

THE PACIFIC | STATE: AMERICAN SAMOA | **ARTIST:** TOM HAUGOMAT

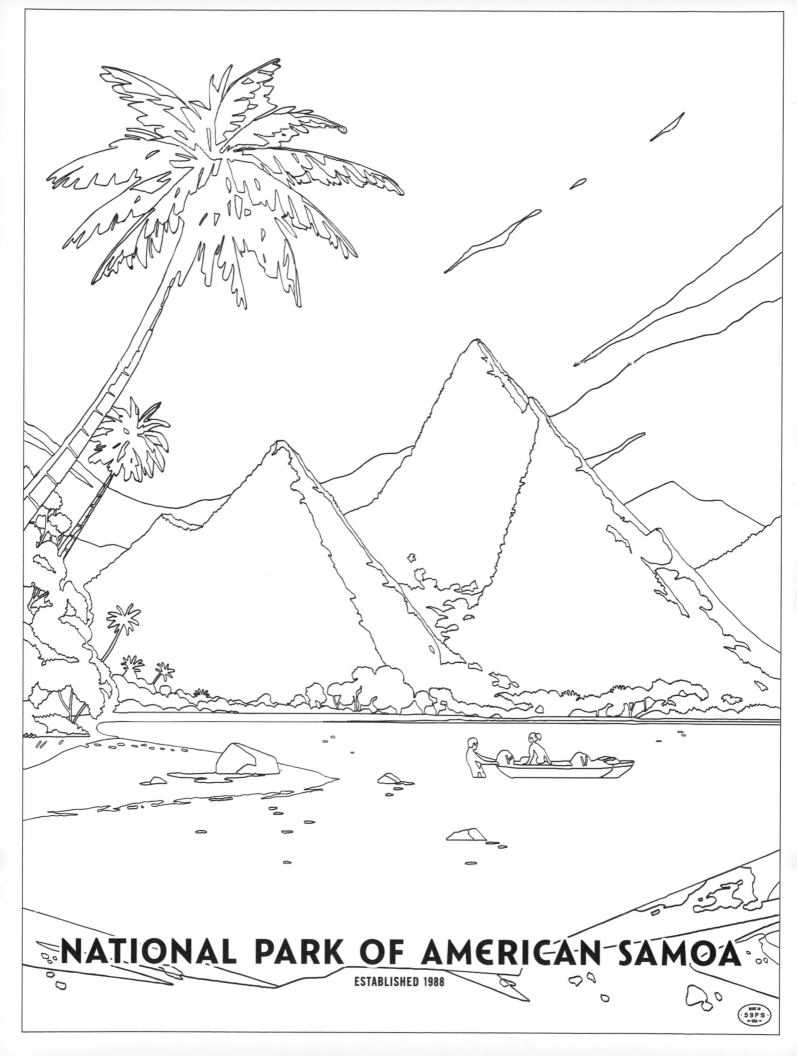

NATIONAL PARK OF AMERICAN SAMOA

ESTABLISHED 1988

ABOUT
Fifty-Nine Parks

Fifty-Nine Parks believes that public lands and the art of printmaking are traditions worth preserving. Each of Fifty-Nine Parks' posters are beautifully screen printed in the United States while collaborating with artists from around the world. The poster series is archived by the Library of Congress and 5% of each poster sale—before profit—is donated to to support the conservation of American public lands. To learn more about the series, please visit 59parks.net.

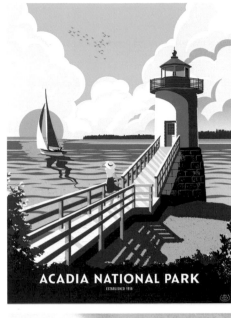

ACADIA NATIONAL PARK
ESTABLISHED 1916

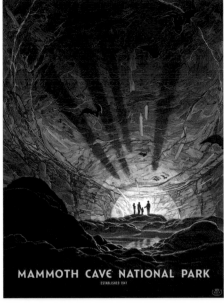

MAMMOTH CAVE NATIONAL PARK
ESTABLISHED 1941

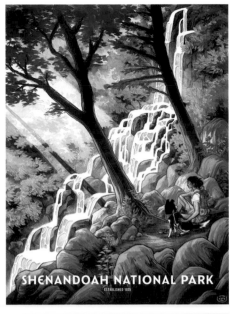

SHENANDOAH NATIONAL PARK
ESTABLISHED 1935

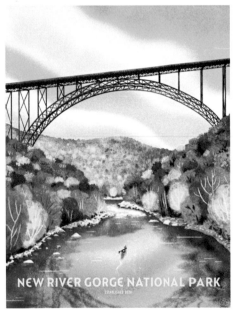

NEW RIVER GORGE NATIONAL PARK
ESTABLISHED 2020

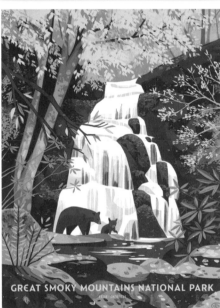

GREAT SMOKY MOUNTAINS NATIONAL PARK
ESTABLISHED 1934

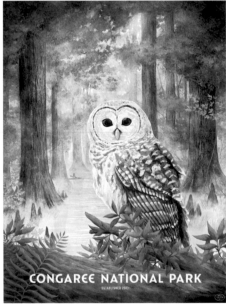

CONGAREE NATIONAL PARK
ESTABLISHED 2003

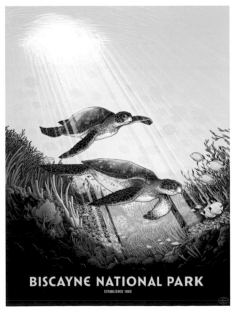

BISCAYNE NATIONAL PARK
ESTABLISHED 1980

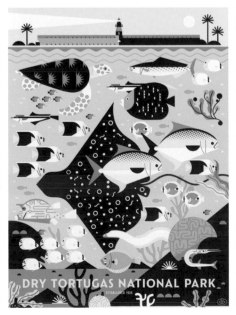

DRY TORTUGAS NATIONAL PARK
ESTABLISHED 1935

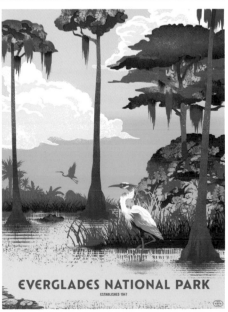

EVERGLADES NATIONAL PARK
ESTABLISHED 1947

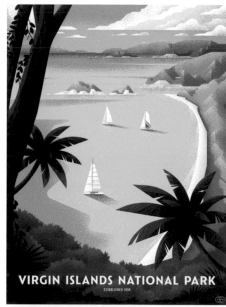

VIRGIN ISLANDS NATIONAL PARK
ESTABLISHED 1956

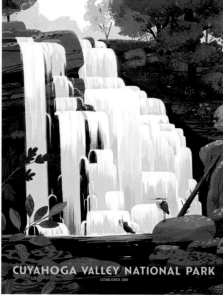

CUYAHOGA VALLEY NATIONAL PARK
ESTABLISHED 2000

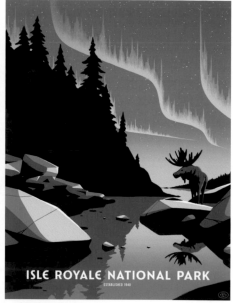

ISLE ROYALE NATIONAL PARK
ESTABLISHED 1940

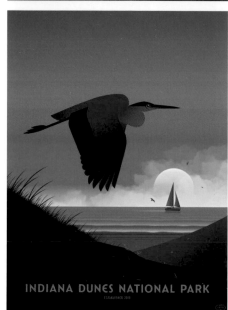

INDIANA DUNES NATIONAL PARK
ESTABLISHED 2019

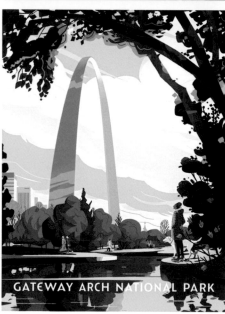

GATEWAY ARCH NATIONAL PARK

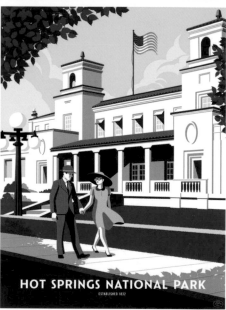

HOT SPRINGS NATIONAL PARK
ESTABLISHED 1832

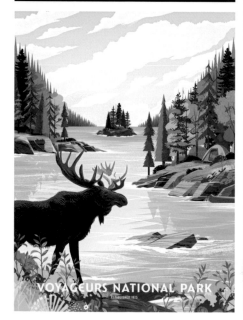

VOYAGEURS NATIONAL PARK
ESTABLISHED 1975

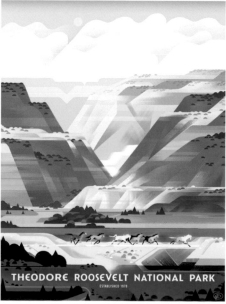

THEODORE ROOSEVELT NATIONAL PARK
ESTABLISHED 1978

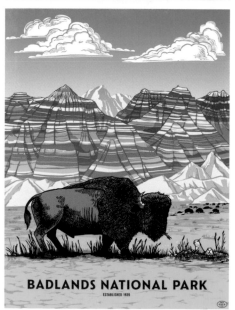

BADLANDS NATIONAL PARK
ESTABLISHED 1939

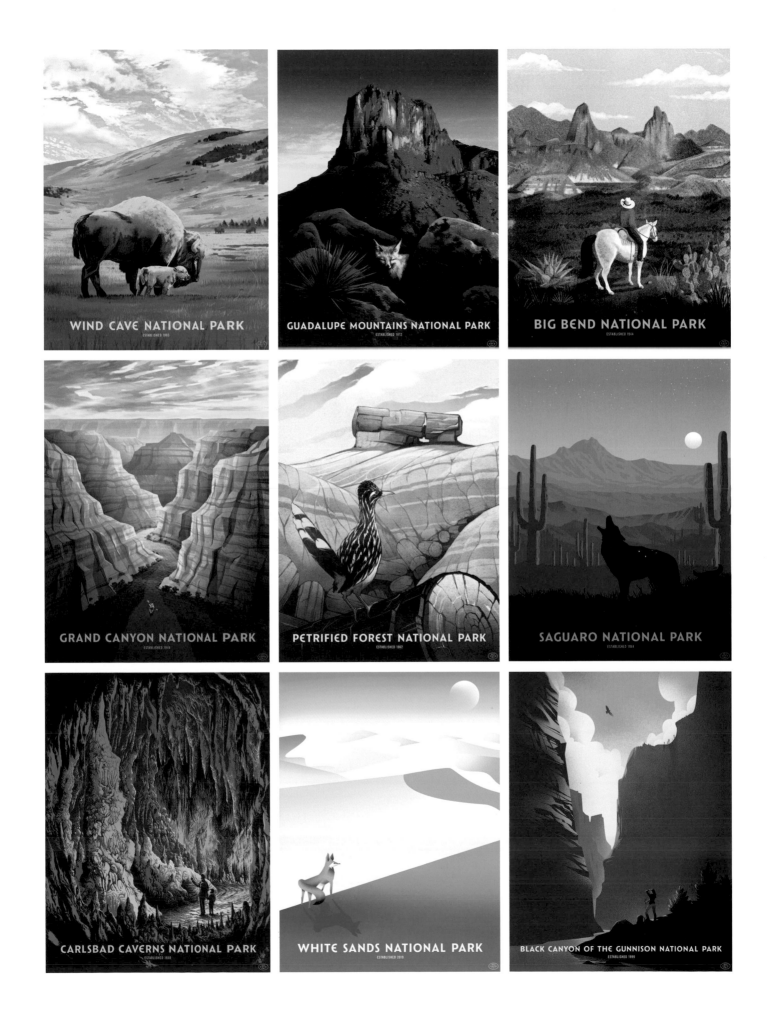

WIND CAVE NATIONAL PARK
ESTABLISHED 1903

GUADALUPE MOUNTAINS NATIONAL PARK
ESTABLISHED 1972

BIG BEND NATIONAL PARK
ESTABLISHED 1944

GRAND CANYON NATIONAL PARK
ESTABLISHED 1919

PETRIFIED FOREST NATIONAL PARK
ESTABLISHED 1962

SAGUARO NATIONAL PARK
ESTABLISHED 1994

CARLSBAD CAVERNS NATIONAL PARK
ESTABLISHED 1930

WHITE SANDS NATIONAL PARK
ESTABLISHED 2019

BLACK CANYON OF THE GUNNISON NATIONAL PARK
ESTABLISHED 1999

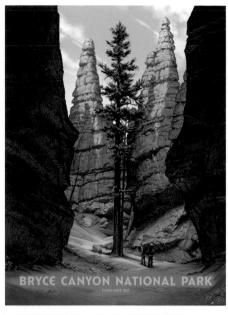

BRYCE CANYON NATIONAL PARK
ESTABLISHED 1928

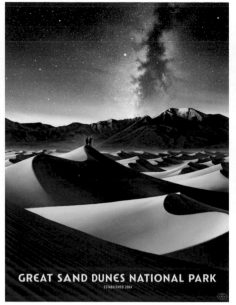

GREAT SAND DUNES NATIONAL PARK
ESTABLISHED 2004

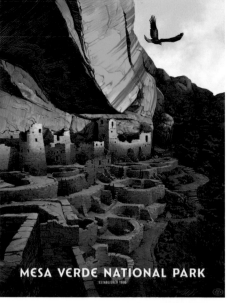

MESA VERDE NATIONAL PARK
ESTABLISHED 1906

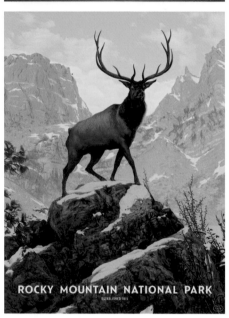

ROCKY MOUNTAIN NATIONAL PARK
ESTABLISHED 1915

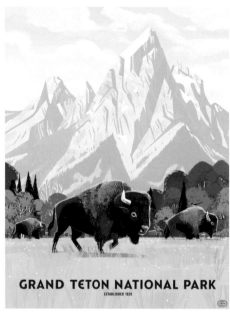

GRAND TETON NATIONAL PARK
ESTABLISHED 1929

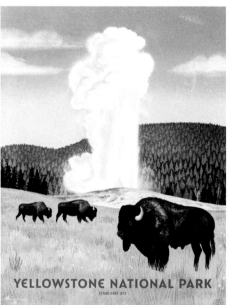

YELLOWSTONE NATIONAL PARK
ESTABLISHED 1872

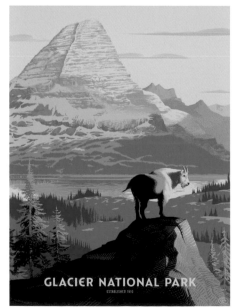

GLACIER NATIONAL PARK
ESTABLISHED 1910

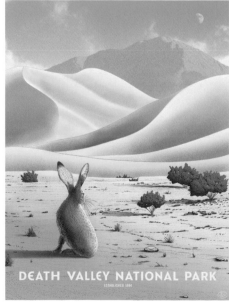

DEATH VALLEY NATIONAL PARK
ESTABLISHED 1994

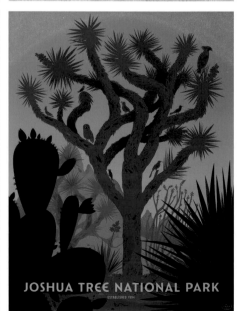

JOSHUA TREE NATIONAL PARK
ESTABLISHED 1994

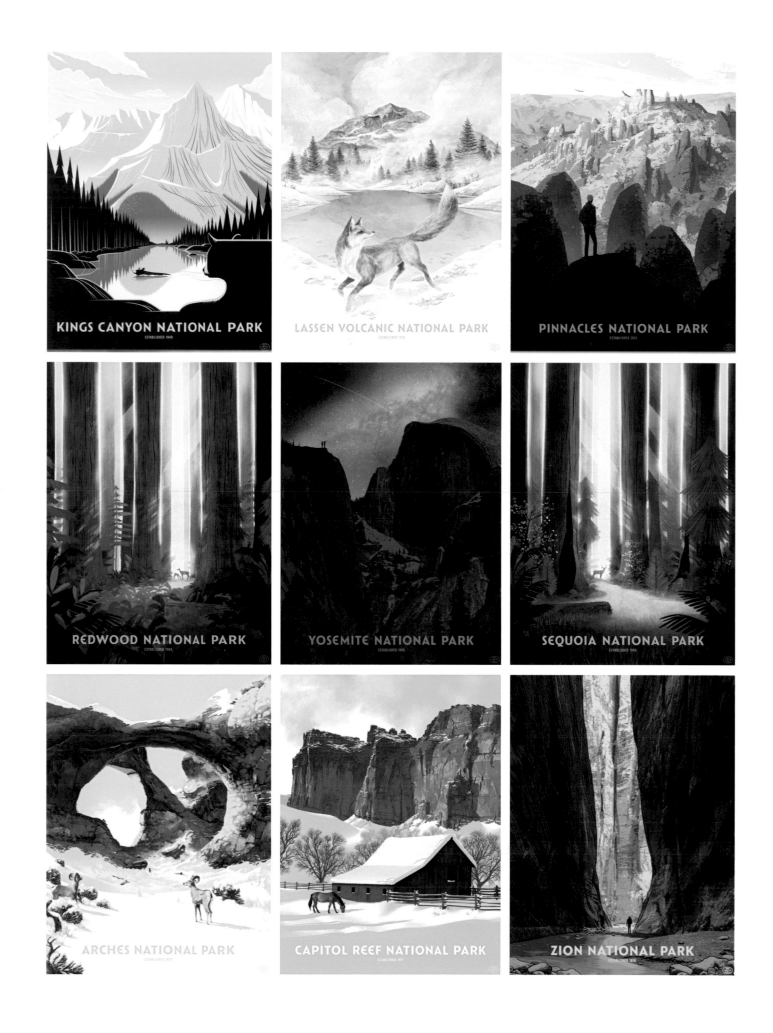

KINGS CANYON NATIONAL PARK

LASSEN VOLCANIC NATIONAL PARK

PINNACLES NATIONAL PARK

REDWOOD NATIONAL PARK

YOSEMITE NATIONAL PARK

SEQUOIA NATIONAL PARK

ARCHES NATIONAL PARK

CAPITOL REEF NATIONAL PARK

ZION NATIONAL PARK

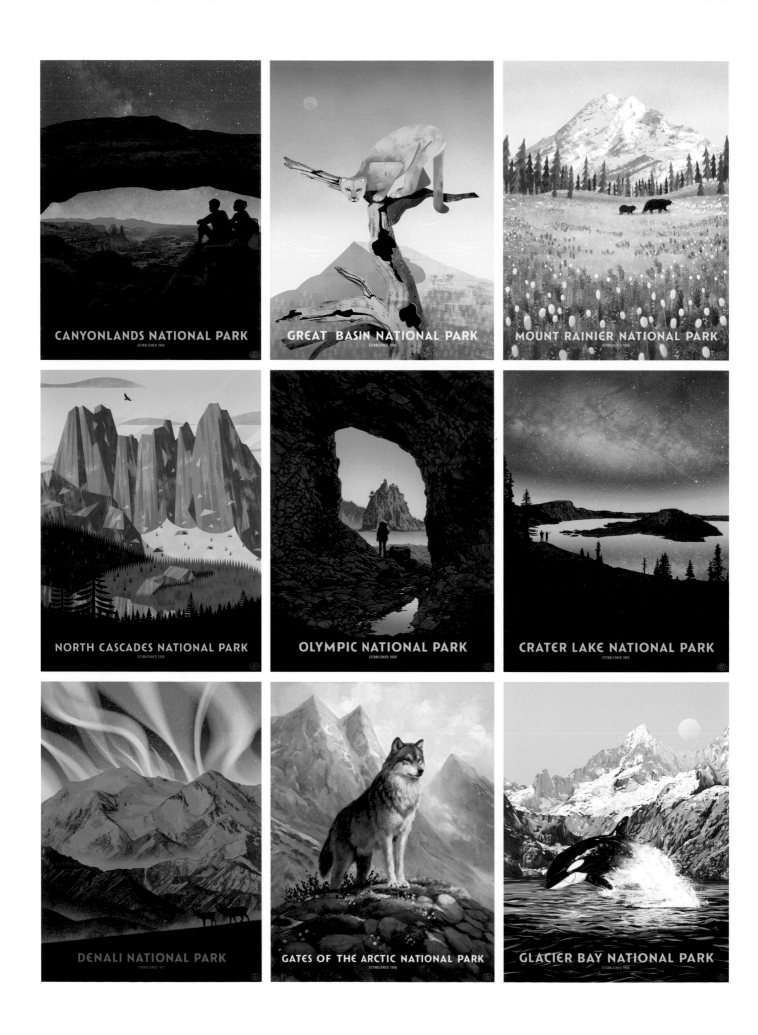

CANYONLANDS NATIONAL PARK
ESTABLISHED 1964

GREAT BASIN NATIONAL PARK
ESTABLISHED 1986

MOUNT RAINIER NATIONAL PARK
ESTABLISHED 1899

NORTH CASCADES NATIONAL PARK
ESTABLISHED 1968

OLYMPIC NATIONAL PARK
ESTABLISHED 1938

CRATER LAKE NATIONAL PARK
ESTABLISHED 1902

DENALI NATIONAL PARK
ESTABLISHED 1917

GATES OF THE ARCTIC NATIONAL PARK
ESTABLISHED 1980

GLACIER BAY NATIONAL PARK
ESTABLISHED 1980

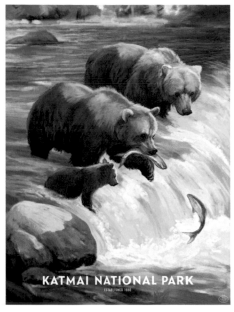

KATMAI NATIONAL PARK

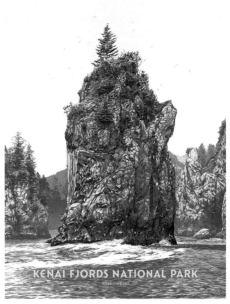

KENAI FJORDS NATIONAL PARK

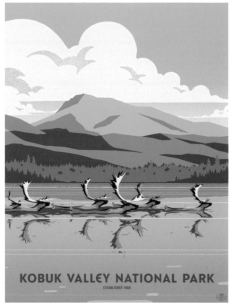

KOBUK VALLEY NATIONAL PARK

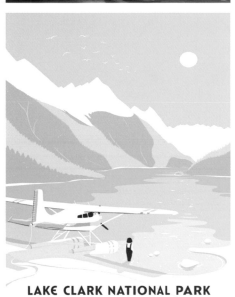

LAKE CLARK NATIONAL PARK

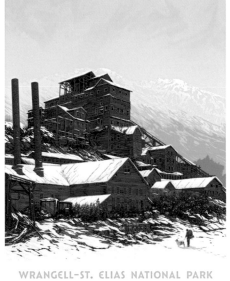

WRANGELL–ST. ELIAS NATIONAL PARK

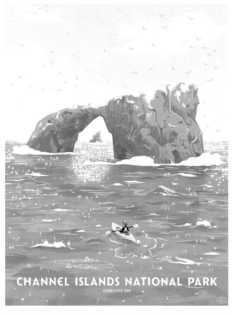

CHANNEL ISLANDS NATIONAL PARK

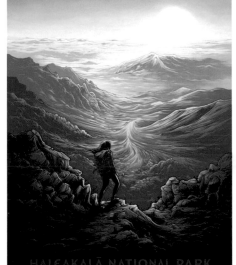

HALEAKALĀ NATIONAL PARK

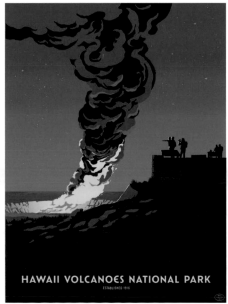

HAWAII VOLCANOES NATIONAL PARK

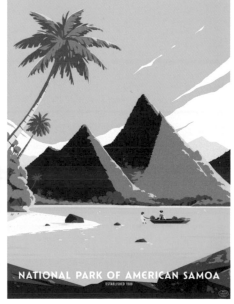

NATIONAL PARK OF AMERICAN SAMOA

INDEX

Fifty-Nine Parks

www.59parks.net

Find us on Instagram: @fiftynineparks
Follow us on Twitter: @fiftynineparks

EARTH AWARE

An imprint of MandalaEarth
P.O. Box 3088
San Rafael, CA 94912
www.MandalaEarth.com
Find us on Facebook: www.facebook.com/MandalaEarth
Follow us on Twitter: @MandalaEarth

Publisher: Raoul Goff
VP Publisher: Roger Shaw
Editorial Director: Katie Killebrew
Editor: Claire Yee
Editorial Assistant: Amanda Nelson
VP Creative: Chrissy Kwasnik
Designer: Brooke McCullum
VP Manufacturing: Alix Nicholaeff
Production Associate: Tiffani Patterson
Sr Production Manager, Subsidiary Rights: Lina s Palma-Temena

ISBN: 978-1-64722-732-6

 ROOTS of PEACE **REPLANTED PAPER**

Insight Editions, in association with Roots of Peace, will plant two trees for each tree used in the manufacturing of this book. Roots of Peace is an internationally renowned humanitarian organization dedicated to eradicating land mines worldwide and converting war-torn lands into productive farms and wildlife habitats. Roots of Peace will plant two million fruit and nut trees in Afghanistan and provide farmers there with the skills and support necessary for sustainable land use.

Manufactured in China

First printed in 2022.

10 9 8 7 6 5 4

2023 2024 2025